# SUN BIRDS
# AND
# EVERGREENS

## The Nuk-Chuk Stories

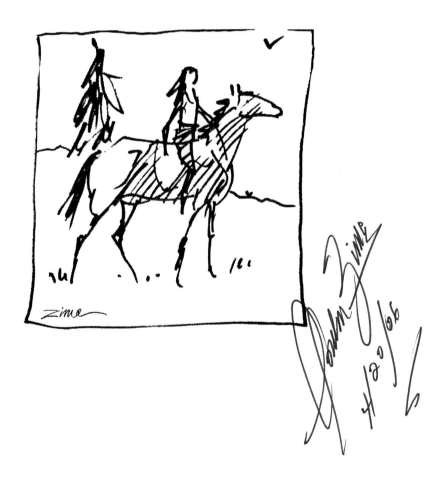

# SUN BIRDS AND EVERGREENS

## The Nuk-Chuk Stories

### Gordon Zima

*with illustrations by*
*Paula Zima*

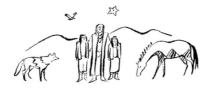

*HuttonElectronicPublishing.com*
*160 North Compo Road*
*Westport, Connecticut 06880*

Published by HuttonElectronicPublishing
160 Compo Road North,
Westport, Conneticut, 06880
huttonelectronicpublishing.com

© 1994 Gordon Zima

*Library of Congress Cataloging-in-Publication Data*

Zima, Gordon.
Sun birds and evergreens : the Nuk-Chuk Stories /
Gordon Zima ; with illustrations by Paula Zima.
p. cm.
Summary: A young Indian named Nuk-Chuk is drawn to
the teachings of his ancestors amid the promise of
the new life offered at school.

ISBN 0-9742894-9-3 (paperback)
ISBN 0-9742894-5-0 (hardcover : alk. paper)

1. Indians of North America--Northwest, Pacific--Juvenile fiction
[1. Indians of North America--Northwest, Pacific--Fiction.
2.Manners and customs--fiction. 3. Rite and ceremonies--Fiction.]
I. Zima, Paula, ill. II. Title.

PZ7.Z544Sun 1994
[Fic]--dc22
2005014001

Printed in the United States of America

These stories of the Pacific Northwest
were inspired by the indigenous people
of this region and are made of
some fact and some fantasy.

I dedicate them to three of my ladies...
M and A and P...
who were voracious listeners.

## The Stories

# 1. THE MARKING TREE

This tree was a spruce kind of giant, and it had been pushing its strength against the world for a great counting of years. Now, there was nothing of the Land that could challenge it. When the rainstorms and the strong puffs of wind bent the ferns over the feet of this giant, even the tallest ferns couldn't touch their heads to the great body that seemed to hold up the sky.

Nuk-Chuk used the feet of the tree for his steps as he climbed toward the body of it, over a trail made of big pieces of bark and smooth muscles of living wood. Where the feet were fastened to the body, they made a grotto where one could find shadows even under the strongest sun. He walked into this grotto and put his hands where the bark had gone from the body. He thought he could feel the giant breathing. Stepping farther into the grotto, he found a place that was like a smooth wall...much taller then his head. He moved his fingers all around this wall. When he put his ear against it, he could hear sounds like whispers.

1

He could make this a private place for himself where he could say words without explanation to anyone, and if he had to make some laughter—or some silence—between the words, then nobody but this tree and Nuk-Chuk would have to understand.

His hands touched some marks on the wall where things that had happened to the tree had left memories...perhaps a fire, or a powerful wind...the scratch of a bear's paw, or a mountain lion's tooth. He wondered if *he* could leave some memory of his own in this place that seemed to be very close to the heart of this great one.

He put his ear against the smoothness again and he listened very carefully. He heard the talk between the wind and the tree. The wind was strongest near the head of the tree and when the wind started to brag about its strength, Nuk-Chuk thought he could hear laughter. When he stretched his imagination as far as it could go—pushing his ear against the wall as hard as he could—he thought he could hear his own name floating down the great body along with some of the laughter. He knew laughter could have either smiles or frowns in it. *This* laughter seemed to have plenty of smiles. So, he started to think about the marks that he would make on this wall that would say *Nuk-Chuk* to this father of trees.

He climbed away from his new friend and stopped not far from where the great feet went down into the lower world. This was a good place to look at the Land.

In the direction of his right hand, he could see the valley where the river they called *Dragon* wiggled its way to the ocean. The salmon fish came up this river, and someday he would like to try his strength against a very big one of these silvery fish.

One of the rounded hills near the Dragon had some horses on it. Some of them chased each other, and some of them chased the wind. He would like to have a *wind* kind of horse someday. A horse that would let him challenge many places of the Land and even some of the places where pieces of the Land and the sky were so mixed together that the top and bottom of everything was sometimes hard to find.

In the direction of his left hand, he saw the lake, and the place where the Dragon entered it in a great tumble of white water. He saw where the Dragon left the lake, hurrying toward the ocean. Some of the People had told him that there were islands and fingers of the Land in this lake that had magic in them. Some day he would like to test the waters of this lake with his friends, and then they could look for some of this magic.

A bird call cut the body of the air like a knife and pulled Nuk-Chuk's eyes to the sky. The golden eagle, calling again, threw a swift shadow that almost swept across his feet. This one, floating far above him, was from a world that could never be his, but even an eagle has to touch the Land once in awhile. Someday,

3

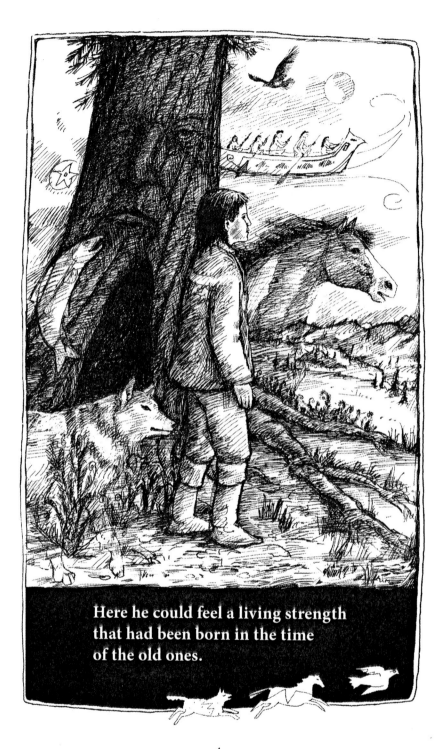

Here he could feel a living strength
that had been born in the time
of the old ones.

he would like to find one of these touching places...then he could talk to the eagle about the sky world, and about some of the parts of friendship.

As he was walking back to his village, still high enough above the floor of the valley to catch the voices that the air had carried from far away, Nuk-Chuk thought he heard the call of a wolf. He stopped walking, trying to trap every piece of the sound that had just pulled up the hairs on the back of his neck. If this *was* a wolf, then he had just heard the voice of a powerful one, that could travel in the sunlight, and in the black shadows of the night. This one could also laugh at *any* man's cleverness and maybe at his offerings of friendship, too. If he could have a *wind* kind of horse, he would find the strength to take such a horse to the places of the wolf. Then he would bring his courage as close to the wolf as he could get, and he would offer his friendship to see what the wolf would make of it.

As Nuk-Chuk came down to his village, the whispers of his new friend seemed to swim with the other sounds and images that had come into his eyes and ears as he had stood next to the great tree. His grandfather had told him not to let go of the places of the Old Ones that were all around him...and to keep awake to the *voices* of the Old Ones that were also all around him.

Nuk-Chuk's teacher at the Agency school, Mr. McPherson, had told him and all his friends that they were standing between their old world and a new world that was pushing at them from all directions. When he thought about Mr. McPherson's words, he decided that they meant the same as his grandfather's words...that he was living in a time of many changes and that his steps into this time would be better if he always remembered the strengths of the People.

Now, he had a private place, a marking place, where he could talk and listen to his new friend. Here he could feel a living strength that had been born in the time of the Old Ones. As he thought about this, he began to know that this strength would help him take the steps that Mr. McPherson and his grandfather were talking about.

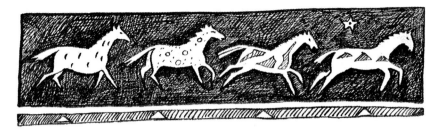

# 2. THE MARK OF TOPI

There came a time when Nuk-Chuk's hands were strong enough and his legs were strong enough and long enough to tell a pony what to do. This should have been a good time. But Nuk-Chuk had no pony. Talk Too Fast and Small Beaver and others had ponies. Even White Fawn was talking about the pony she was soon to have.

"Father, when?" Nuk-Chuk would ask his father almost every day, and sometimes several times during the day.

"Soon," was all his father would say.
"Soon," was all his grandfather would say.
"*Very* soon," was all his mother would say.

Then one day, before the sun looked into their valley, a strong hand found Nuk-Chuk under his sleeping robes and it shook the sleep from him.

"It is time for the pony roundup. If you think you are ready, come." his father said. Then he quickly left Nuk-Chuk by himself to make an answer for this big question.

"I am ready *enough*," Nuk-Chuk said to himself. Soon he had put on leggings and moccasins and a shirt and a coat of deerskin to keep out the night cold.

He rode behind his father, holding tightly to a coat that had a wonderful smell of horses and the pine forest. His father's pony carried both of them as if they were nothing. Nuk-Chuk could feel its muscles as it lifted them up into the forest. He would bury his head in the back of his father's coat when the cold wind or the arms of the trees tried to take him from the back of the pony. He could see or hear many other ponies. Once, he heard his name called by one of the other riders, and he heard his father's laugh for an answer.

Finally, as his hands were getting cold and his rump was getting sore, he felt the pony come to a sudden stop. Nuk-Chuk slid off like a sack of corn. He ended his journey flat on his back, staring up at a circle of faces that grinned and laughed. Quickly he stood up and then he made himself very busy helping to find wood for the fire.

There was now dawn light and he could see many men and ponies. When the fire came alive, he moved close to it; he loved its heat and light and smell. The flames' dance made the men and ponies look like gods of the forest. He thought he could see other gods back in the forest, waiting their turn by the fire. Soon there was a circle of men around the fire with much talk.

Nuk-Chuk squeezed into the circle between his father and grandfather. He was a tiny, very quiet lump among big lumps, which never seemed to look at him. But they *did* look at him

and the firelight could show smiles that he couldn't see. He was sleepy, and the talk came to him only like a deep rumble as he moved closer to the great coats of his father and grandfather.

"You will come with me." his grandfather said, pulling Nuk-Chuk to standing beside him. "We are to go to the place of the corral and wait for the drive to bring us the ponies." His grandfather lifted him to the back of another pony and very soon Nuk-Chuk was holding tightly to another coat. This coat smelled good, like his father's. It had some fish smell, but it was good and warm.

The pony took them higher up the mountain, across brooks that made water sounds and stone sounds when the pony crossed them. Mostly, Nuk-Chuk heard only the soft patter of pony feet against the moss and pine needles of the forest bed. Then they were going down into another valley. Once, the pony jumped a small log and he heard his grandfather laugh. Many times he had to hold his grandfather's coat to keep from sliding off the pony. Several times his grandfather's hand found him just in time to keep a sack of corn from falling into a thorn bush. After much slipping and holding tightly to a coat, some laughing from one throat, and finally from two throats, the pony stopped.

Nuk-Chuk could see two long lines of log fences that came together near where they had stopped and then the lines separated again, fading into the whiteness of the morning. He knew that he was now standing at the mouth of the great pony trap. He had heard much talk about this trap. Small Beaver and Talk Too Fast had talked about it. Now he could talk about it.

"We can have no fire and must be very quiet," his grandfather said as he led the pony into the mouth of the trap. He slapped the pony on the rump. The pony jumped, threw its head upward, and then with a snort to them it turned and ran into the trap.

Nuk-Chuk's stomach was starting to cry a little. He said nothing of this, but grandfathers understand stomachs very well. Soon Nuk-Chuk was chewing on a big piece of jerky. He tried to do this as well as his grandfather, but sometimes his teeth and the jerky got into little fights, which the jerky usually won.

"…And if the pony god is good to you, what would you like?" his grandfather asked him. The cold was forgotten now. His stomach no longer cried. Nuk-Chuk climbed to the top of the fence and let his legs hang down, like he had seen the men do many times. He looked around him. He looked above him. The morning whiteness still ruled most of what he could see. He trembled a little, trying very hard to hide this from his grandfather. When he finally looked at the place where the big question had come from, his eyes were too big and bright to hide the dance of his heart.

"I would like a pony that is a little too big for me. I would like a pony that is a little too fast for me…when he wants to be. I would like…"

"Such a young mouth to have such a pony," his grandfather said, using a grin that captured almost all of his face. "What about color? Like a spotted fawn so he can fool the mountain lion?

Like a frog…so he can walk the lake shore and wade the rivers unseen? Like a sagebrush…so the plains can hide him from the eagle?" His grandfather walked toward him as he said these things. At the last, a big hand was resting on a small knee and two smiles came together.

"I would like him to be black, or white, or brown, or gray… or any of these together," Nuk-Chuk answered. Just as he said this, they heard a sound like small thunder coming from the mountain. His grandfather scooped him up and ran away from the mouth of the trap. He finally stopped back in the forest where the ferns and boughs could hide them. And then they lay in the long grass, which still held much of the morning wetness.

"They are coming," his grandfather whispered and Nuk-Chuk's heart leaped against the wall of his chest. Then a great rumble of horsesounds poured over them like water over the cliffs in the Dragon. Nuk-Chuk couldn't speak, but he couldn't be heard anyway. His grandfather let him raise his head just enough to look toward the mouth of the trap.

The ponies came out of the forest and the whiteness swirled around them. There was a great lead mare. And then there were more mares, and foals and young stallions, giving another storm of heads and tails and flashing legs. There seemed to be a wall of horsesounds and eyes and teeth and flashes of black and white and brown. It was all the colors of every pony that ever was. Nuk-Chuk had never heard such a horsesound, had never felt the earth moved by bodies of horses. He didn't know that he squeezed his grandfather's hand very hard. Then he saw his father and the other men riding behind the last of the ponies…

11

shouting and laughing and waving false spears and blankets. When the last of the pony flood had poured into the trap, two men sealed it with log rails. Then there was a wonderful shouting from all the voices and Nuk-Chuk's was part of this.

Everyone sat on the fence rails and looked into the corral. The ponies had not yet decided that the trap was good and they flattened the grass and threw pieces of earth with feet that made their own wind. The hairs on Nuk-Chuk's neck stood like the quills of a porcupine in his wonder at this sight. Soon the men were making their rope loops settle on the necks that pleased them. There were many contests between men and ponies. Some of these the man won, some the pony. Above it all, there was a roar of horse sound that made Nuk-Chuk almost cry to become a part of it.

His father came toward him, a long rope coiled in his hand, the big catching loop swinging beside him. "We find none with wings to fly, or fins to swim," he said, letting a big wink fly toward his grandfather.

"...Or a frog color...or like a fawn, or sagebrush?" his grandfather asked, the big grin stealing his face again.

"But there *is* a black and white pinto who is perhaps a little too big for you...maybe too fast for you." His father pointed to a place in the corral.

And there was such a horse. He was standing by himself. He looked a little angry. He looked very proud. And he looked like the world was very new to him. Except for the anger, this

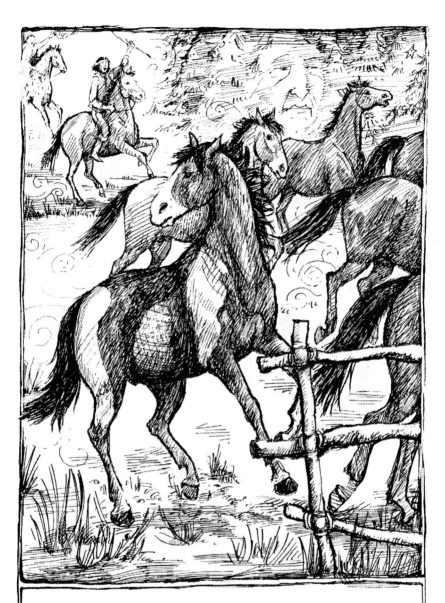

Then he saw his father and the other men riding
behind the last of the ponies…shouting and
laughing and waving false spears and blankets.

horse could share all of these things with Nuk-Chuk. Nuk-Chuk's eyes told his father and grandfather all they needed to know. His father went into the corral and, after one try, his loop settled on the neck that Nuk-Chuk knew was the best neck in that corral. Then his father handed him the rope. Everyone was very still, and there was no more talk.

The pinto jerked his head toward the sky and Nuk-Chuk could feel his power flowing along the rope. It frightened him a little, but he didn't lose his hold on the rope. He knew his father and grandfather were close to him. He knew that many others were watching him. But, for Nuk-Chuk, there was only one other in that corral with him. This one was watching him with great black eyes that seemed to bore into him and search for the strength in him.

Very slowly, Nuk-Chuk pulled himself toward the pony, keeping the rope tight, but not too tight...his hands firm on the rope, yet not too firm, as his father had taught him. When he was within a pony's length of the soft black nose and the flared nostrils and the black eyes, Nuk-Chuk stopped. His legs were trembling, but he thought only of meeting the challenge of the black eyes and of touching the softness in front of those eyes. He put out his hand. The pony reared and ran toward the fence. He couldn't show his best swiftness because he was dragging a small bundle along the ground. This bundle wouldn't let go of the rope although it burned his hands and the ground pounded

his body. Nuk-Chuk saw many horse legs and heard many horse sounds when the grass and earth didn't fill his ears. He would never let go of that rope, even if his arms were pulled away from him. Finally, there was an end to the pounding.

Nuk-Chuk slowly raised his face from the ground. Leaning on the rope, he pulled himself to a man's position. The black eyes and the softness were closer to him now. And they didn't go away when Nuk-Chuk placed one hand, and then the other, on head fur that was wet with sweat. The sweat on *his* face mixed with the other for a moment and then he turned toward his father and grandfather. They were thinking much, but they said nothing. Finally his grandfather came to him:

"And what will you call this eagle of horses?" he said.

"I have called him *Topi*," Nuk-Chuk answered, telling his grandfather that he had given much thought to this question long before he came to this corral.

"Topi," his grandfather said slowly, his voice going into the little breeze that had just found them. "It is a name that should carry well on the wind. And I think that you and this horse and the wind will have much to do with each other." And that is how Topi came to Nuk-Chuk.

"This…private place…is a long way from here?" his grandfather asked, as Nuk-Chuk led the way out of the village toward the hill of his new friend. This was only one day after Topi and he had come together. Nuk-Chuk *had* to make a special mark.

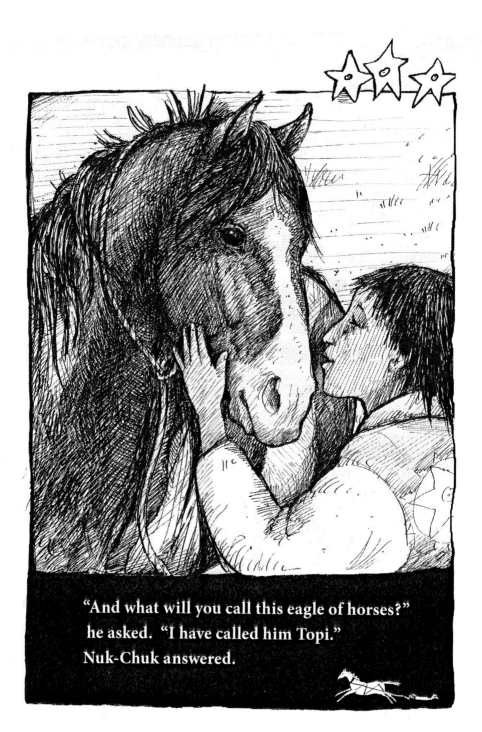

"And what will you call this eagle of horses?"
he asked. "I have called him Topi."
Nuk-Chuk answered.

16

"Not far," Nuk-Chuk answered, as he tried to act like a very old scout, just as he was trying to match the long steps of his grandfather.

"If you show me this private place it won't be so private anymore," his grandfather said when they were far enough up the hill to see the head of his friend. Nuk-Chuk was starting to puff. His grandfather certainly could walk fast and he could also make words that made Nuk-Chuk think. As he walked, he took too long to make an answer, so his grandfather did it for him. "But if somebody says that Nuk-Chuk has gone to his private place, then it would be good for somebody to know about this place... someone who can keep a secret." They didn't look at each other because small steps were trying very hard to match big steps. Also, it was a good answer. No words were needed and not even any looks.

They stopped where the feet of the giant started to climb toward the great body. His grandfather knew this tree very well; he could even find a name for it in his memory, but this was Nuk-Chuk's time. They both looked up at the top of the body where the head of his friend moved against the blue bowl of the sky. Only the air made any sounds in that moment. Then Nuk-Chuk led the way up to the grotto.

Inside it was cool and quiet. The shadows were as good as he remembered. He went to the wall of the smooth strength and touched one of the old marks.

"Perhaps the mountain lion has already heard about this place," his grandfather said, walking close to where a young brave was listening to the heart of his friend. His grandfather put his hand on top of Nuk-Chuk's head and then he moved the head a little

so that it touched the wall. "We should make a head mark if you are going to be bringing part of your life here." He took out his knife and made a mark on the wall…a thin line that told how high Nuk-Chuk's head could go to the sky at that time. As he made the mark, he had to keep pushing that head toward the ground to keep all of the lies out of that mark.

Nuk-Chuk touched the head mark, and then he moved his hand to a smooth place near it. His fingers traced a little image on the new place. Then he used his own knife to put this image a little way into the wall. His grandfather watched without any words. When Nuk-Chuk was done with his image, he stepped away from it and studied it. His grandfather came close to the new mark and also studied it. It was a good mark because it left plenty of room for the cleverness and the skill to grow along with the head marks.

"I like your mark of Topi," his grandfather said. "Now we can watch both of you grow up." As he said this, he touched the head mark and then he let his fingers trace the image of Topi, just like Nuk-Chuk had done.

As they walked back toward the village, there still were not many words. Nuk-Chuk's private place wasn't secret anymore, but he was walking with an older brave who was a famous keeper of the secrets.

18

# 3. THE LONG NOSED ONE

"Look at you!" Mr. McPherson said one day in the big room at the school. "You may think you're leaping into the twentieth century...but you have a *long* way to go." He had been talking again about the new world and the new ancestors that were poking their noses into the Land, and what the People were going to do about it.

"You have your own traditions and culture." He had explained these words to them very carefully. "These new ones are part of another tradition and culture. You must learn to blend all of this together in an honorable way if you are to have a good life here, or someplace else." He moved his hands far apart to show the big distance between the old and the new. Then he brought his hands together fast to show how the old and the new were coming at them. He looked at each of them, trying to see if his words had fallen into the ears where they were supposed to go.

Then he had to smile when the old and the new they had already blended leaped out at him. The pants, leggings, skirts, blouses, vests, shoes, and moccasins in front of him had dipped into the new materials...the denims, the new trade cloths, and the special

19

leathers. And they still carried much of the old materials with them…the deerskin, the moosehide, the handweavings of wool and plant fibers…the bead and stone and ivory ornaments, and some little flashes of brass and silver. His words made the looks fly around that room and they also made some smiles, a few very straight faces, and some big eyes. Nuk-Chuk's look got  tangled with Talk Too Fast's…then with Small Beaver's, and then Little Turtle's. When it went to where White Fawn was sitting, she kept it longer than the others. She was wearing a deerskin band about her head. This band had some of the little beads that her mother knew how to sew into colored magic that pulled eyes very close to it.

They thought that they understood most of what Mr. McPherson had been talking about. They knew much about the *old* and some about that *new*. Each of them was taking steps toward that blending…mostly different steps and some of them were moving faster than the others.

Near Nuk-Chuk's village, the Dragon pulled its tail through the forest. It also jumped down cliffs and ran along the deep canyons that some giant had cut into the mountains. In the spring, the Dragon was not friendly. It told this to anyone with ears to hear its growl and eyes to see it carrying big pieces of trees and earth into its den. In the summer, the Dragon became a friend to anyone who could find joy when the sun danced with its water and when the flowers and long grasses came very close to it. In these times, one could still hear small growls when the rocks and the canyons made it leap and run more swiftly. Mostly, it was a time when the Dragon's voice was soft and it called out for

play under the blue bowl of the sky. This voice could be heard very well by Nuk-Chuk and his friends.

A short pony ride from the village there was a place where the Dragon had piled a great mound of golden sand. This sand had been stolen from many brooks and streams that were too small to argue. It was wonderful stuff for making faces and all the animals they knew. It was also very good for digging caves and tunnels. Those who dug these things had been told to never go too deep into the sand, in case the building went badly, and to never do any digging unless others were there. A few tunnels and caves had gone badly for Nuk-Chuk and some other diggers. After this, they were very careful not to put too much sand over their heads.

Mr. McPherson had told them about castles and shown them pictures of these strange buildings with high walls and the towers with bright flags. Nuk-Chuk had thought about these castles while he waited for the season of the good sand. He also thought about that blending that Mr. McPherson had made into a big challenge for them. He had talked about these things with White Fawn and Talk Too Fast and Small Beaver. Now, they *had* to make a castle.

"I would like more towers," White Fawn said, as she looked at the drawing Nuk-Chuk was making of the castle on a flat place they had made in the sand.

"How many rooms should it have?" Small Beaver asked, as he also studied the drawing in the sand.

"We will have more towers and higher walls," Nuk-Chuk said as he smeared his lines and started to make new ones.

"I think that four rooms would be good," he said, and then he started to make more lines to show his thoughts. Finally there was no argument, only much digging and piling of sand. There was also laughter and spitting of sand from lips and brushing of sand from eyes and hair.

They dug away the sand to leave a great center mound for the house part of the castle. The sand that they moved was piled into a ring for the walls.

"White Fawn is very good with walls," Nuk-Chuk said.

"Let her do them. We will do the house part."

"My towers will be high and made strong with sticks," Talk Too Fast said.

"My windows will be large and many," Small Beaver said. "We will see the flags and towers from the rooms."

"If your windows are too large and too many, all we will see will be the sky when the sand crashes on our heads," Nuk-Chuk said. His face was already almost a sand face. Sand had also found White Fawn's nose and Talk Too Fast and Small Beaver had eyebrows and chins made of sand.

They had made their plans too big and much sand had to be moved before White Fawn could begin her walls. Every evening while this work was being done, the fathers and mothers of the workers would try to keep most of the sand outside their lodges. Sand building is hard work and it is very good for appetites and sleep. The builders talked very little about their work to others. All Nuk-Chuk and White Fawn would say to their mothers was that they would like many strips of cloth with bright colors.

Talk Too Fast and Small Beaver asked for more tools and they also looked for long, straight, sticks. When the sun started to look into their valley on the digging days, the diggers would hurry their first meal so that they could go to the work.

Finally, White Fawn could start to shape her walls. Nuk-Chuk dug a tunnel into the house mound and he passed the sand out to Small Beaver in a basket. He dug tunnels to the places where they would have the rooms. He did well, although the sand kept good talk and good listening from his mouth and ears. When there was room enough, Talk Too Fast also dug in the mound and handed baskets of sand to Small Beaver. Small Beaver was very busy.

"Look! Look!" Small Beaver shouted to everyone. White Fawn came close to look, and then two moles named Nuk-Chuk and Talk Too Fast came out of the mound to also look. A carved stone lay in the basket. It was about the size of a man's hand and it was made in the shape of an animal. But none of them had ever seen such an animal. It had a very long nose, big ears, and two long teeth that curled out of its mouth and went halfway to the end of the nose. These teeth were carved out of the ivory they all knew very well. The body was polished very smooth. As they passed it from hand to hand, they knew that it was a great treasure. They placed it on a flat rock near their work. Often they would stop and look at it. The sun made it come almost alive for them.

When the rooms were made, many baskets of sand had passed to Small Beaver and White Fawn. There had been more cries of

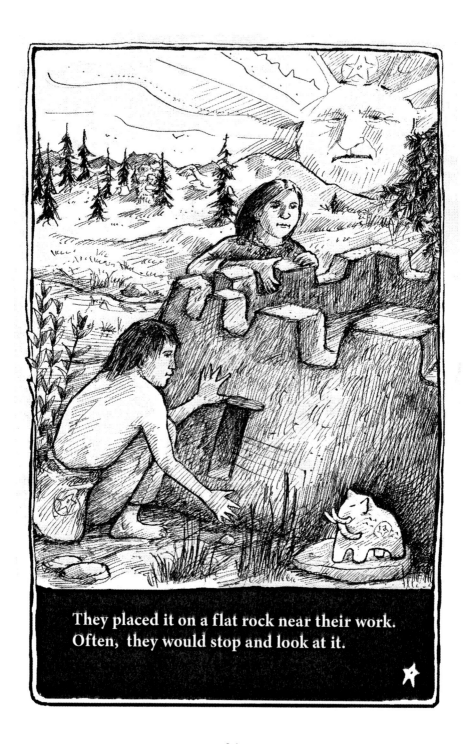

They placed it on a flat rock near their work.
Often, they would stop and look at it.

24

*"Look! Look!"* but no more carvings of the long nosed one. The other treasures were small carvings of ivory that were images of birds and fish and some that looked like deer and buffalo. They placed these near the long nosed one and all of these wonders that had come from the sand made it very hard to continue the work.

"Another tower near that corner...and make it very tall," White Fawn said, brushing away some sand that was trying to hide a big smile. "My mother's ribbons will look proudly from there," she said. Soon many ribbons were looking like that from all the towers. Talk Too Fast had been very good with the towers after he had learned to use his hands with gentleness against the sand. Small Beaver had made his windows small and few. Nuk-Chuk had smoothed the walls of the rooms and tunnels so that they could crawl in them if heads and legs and arms were used carefully inside these places. Everybody did small things to the outside of the castle to make it look more like Mr. McPherson's pictures.

Finally, they could do no more to it. They stood away from it and thought that it was very good. Also, they realized they had touched the hands of *their* ancestors. The breeze came and moved the ribbons on the towers and there were lights in four pairs of eyes that danced with these ribbons.

They placed some of the small ivory treasures around the top of the castle and two of them they put on the wall on each side of the place they called the drawbridge. They put the long nosed one out in front of the drawbridge. Surely he looked like he belonged to castles with bright flags snapping against a blue sky.

They couldn't hide the castle for long. Soon, many came from the village to see the castle and the treasures. There were many questions, many answers, and more smiles than questions. Some of these smiles belonged to Mr. McPherson.

"The long nosed one is from the Old Ones," Nuk-Chuk's grandfather said, as he showed it to Nuk-Chuk's father, and then he handed it to the chief of the village.

"Sometimes we ask if we have honored the Old Ones by what we do with the life that is given us," the chief said to everyone.

He held the long nosed one up to the sun, turning it to bring a life to its stone and the ivory. "We must try to find new trails to our ancestors... and to the ancestors of the new people who are coming toward us." He turned to get a better look at the sandcastle...and at that moment the breeze and the sun put new excitement into the flags, and the walls and towers that had been taken from the sand.

"This is such a trail," the chief said. "I have much pride in this." He spread his arms apart to show that Nuk-Chuk and White Fawn and Talk Too Fast and Small Beaver were a part of this pride. The chief's head was raised so that everybody who had come to see this bridge between ancestors could hear him. His words also went into the air where some of the Old Ones could hear him.

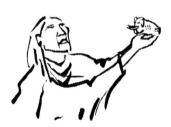

# 4. THE SUN BIRD

The Land was a living thing, and the People had always called it a mother with many voices and many children. In all places, from the darkest parts of the forest to the brightest places of the meadows, this life was fed by the sun, which is the center of all life. The Land also fed on the water that comes from the clouds and from the secret parts of the earth. Of the water food, there was usually more than enough so that the Land could send a big gift of it to the ocean. Often the ocean would send gifts in return. Of these gifts there was none better than the salmon. Several seasons of the year, the great silvery fish would climb from the ocean into the rivers and streams. Here they would plant new life in the white and gold beds of sand.

For many days the men of the People had challenged the salmon with spears, with dip-nets from slippery paths of wood above the clouds of green and white water, and with traps set in the shallow places of the river. Nuk-Chuk helped carry the salmon to the cleaning and drying sheds. He found new strength when he helped his father pull the spear lines and raise the dip nets. He knew some fear when he slipped on the wet wooden paths

above the water. And he heard laughter when his father pulled him from the water with the line tied around Nuk-Chuk's middle. Everywhere there was happy talk and shouting and all the water sounds that could be. Many times, Nuk-Chuk's mother had to use strong words to bring him to his bed during the season of the salmon. Once, late in the night, when his mother came to cover him again, she brushed a silver scale from a face that wouldn't stop smiling.

"What are you making, Nuk-Chuk?" White Fawn asked him one morning when she saw him sitting at the front of his lodge. She was hurrying to the work of the cleaning and drying sheds which could always use more hands, but the bundle of bright feathers in Nuk-Chuk's hands had stopped her.

"I have not yet caught a salmon," he said, not looking up from his work as White Fawn sat beside him.

"You *have*...I've seen you catch many," White Fawn said softly. That pile of bright feathers certainly was interesting.

"Always there were others there...my father, grandfather...other men. My strength did little against the salmon." At the last of his words, he lifted the bundle of feathers to the sun. White Fawn could see a large bone hook inside the feathers. There were red and white and yellow colors and the sun brought them

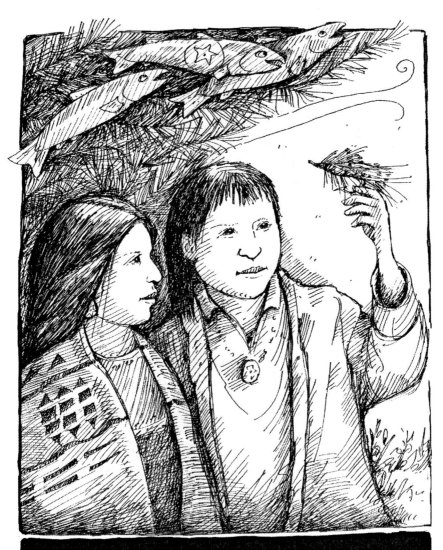

Nuk-Chuk lifted the little bundle
of feathers to the sun.
White Fawn could see a large
bone hook inside of them.

to full brightness. It also brought a little gasp from White Fawn when the sun bird looked down at her.

"It's beautiful," she said. And then "*Ouch!*" when a finger came too close to the hook.

"I made it to catch salmon…not *girlfish*," Nuk-Chuk said. His small laugh took away any anger White Fawn may have been thinking about.

"How will you do this?" she asked, and she rubbed her finger in the cool earth where Nuk-Chuk couldn't see it.

"I will fasten my lure to a long line and throw it into the river. Then, I will pull it across the nose of the *biggest* salmon and I will make him strike it. After this, there will be much pulling." He was not yet a man, but White Fawn saw a man's eyes on him when he said that. Yet, she made a little prayer that the biggest salmon wouldn't come to Nuk-Chuk until he was strong enough.

"My father has much strong line. I could ask him for some. My mother has some silver ribbon that could help your lure catch the sunlight. I could…" White Fawn looked to the ground when her words ran out.

"You could do *many* things if I would let you help," Nuk-Chuk said, trying to use a face that could hide a smile. "You could tangle the line with your legs and I would have to catch a girlfish and not the salmon. Your mouth could make more sound than the river and my lure wouldn't look true to the salmon. If I could find a stupid salmon, your shouts could drive him to an anger that would break my line."

"I could help carry your fish to the village where all could see the mighty fisherman," White Fawn replied, her eyes so big that Nuk-Chuk could see the forest in them, with some sparkle from the sky.

"Perhaps some silver...here...and here...*would* help to catch the eye of the salmon," Nuk-Chuk said as he held his lure up to the sun again and touched some parts of it with his other hand. "Your father's line is very strong?" he asked. He brushed his look against White Fawn long enough to see the smile on her.

Nuk-Chuk was fastening the line to his lure by the way his grandfather had taught him. It was hard work so he didn't see Talk Too Fast and Little Turtle and Small Beaver who had come up to him. When he *did* see them, he said nothing and kept to his work.

"Such a bird would frighten the *chief* of the salmon," Small Beaver said to anyone.

"The salmon could wear it on his head…like a hat," Little Turtle said to anyone.

"This is a bird for the chief of the salmon," Nuk-Chuk finally said. "It will catch his eyes and then his mouth if I can bring enough life to it." He moved the feathers to show the big hook and then he tested the hook's sharpness with the little finger of his left hand. He took some of the silver ribbon White Fawn had brought him and he wrapped it around part of the hook and fastened it with thread. When it was done, he held the lure up to the sun once more and he made it move like a sun bird hunting for the chief of the salmon. This lure hadn't yet caught a salmon, but it had caught four braves and a maiden. Nuk-Chuk was as ready for the salmon as he could be.

The sun was just starting to look into their valley when the sun bird, four braves and one maiden reached the bank of the river. The long grasses had given much of their morning wetness to the walkers, so only the sun bird was thirsty when they came to the large pool where Nuk-Chuk wanted to go. A great splash far out on the water made them all look toward the center of the pool. Again and again the splashes came. Then the young sun showed them where mighty tails and backs were climbing toward the sand beds of life.

Nuk-Chuk had coiled his line in a basket. He had practiced throwing a weight with the line. Now, other eyes were watching him and there was also a great fish target for him that could pull his line and his sun bird away from him if he wasn't strong enough to hold them. He placed the basket near the water. Then he swung the sun bird around his head and gave a mighty heave which should have sent the sun bird far out on the water.

"Ah...the bird is happy. It's found a tree," Small Beaver cried.

"The legs of the salmon will have to be strong to climb to that lure," Talk Too Fast said, almost like a shout.

"If we can kill salmon with laughter, then our portage sticks will be heavy today," Little Turtle said. He laughed, but he also pulled the sun bird out of the tree for Nuk-Chuk.

"Again, Nuk-Chuk...again!" White Fawn shouted.

Nuk-Chuk said nothing. He coiled his line again, stepped to the edge of the water and made the sun bird fly faster and faster until it made a many-colored circle around his head. A voice inside him cried, "Now!" and he let the sun bird fly. It flew toward the center of the pool, the sunlight catching it in its flight, sending little arrows of red and yellow and silver back to them. Then it dove into the river like a fish hawk. The swift current caught the sun bird and pulled much line from the basket before Nuk-Chuk could stop it. He pulled on the line and then let it go. He did this several times, trying to make the sun bird dance in the green clouds. Then a great pull came from the sun bird's end of the line, and the line started to burn Nuk-Chuk's fingers as it went into the water. It stopped for a moment and then Nuk-Chuk gave his best pull on the line. Far out on the pool,

a salmon climbed into the sky. Its body was like a great log of silver, and the sun bird was in the corner of its mouth. When the salmon came back to the pool, it smashed the water into a big shower of drops that tried to make a rainbow with the sun.

Nuk-Chuk couldn't hold the salmon. Little Turtle and Talk Too Fast added their strength and then White Fawn and Small Beaver put their hands on the line that wouldn't stop going into the water. The salmon and the sun bird found the sky again and again and the line pulled the fishermen into the water. Soon, there was almost as much swimming and slipping on mud and rocks as there was fishing.

For a long time they fought the salmon along the pool until they came to a tree that had fallen into the river. With this tree, first Nuk-Chuk and then the others found the strength they needed to stop the slipping and the swimming. Slowly they took back the line from the salmon. Finally, when it was showing its back in the shallows of the pool, Nuk-Chuk and Talk Too Fast leaped on it. Then there was a good wrestling match. It was finally won by the fishermen because of the good grip of the sun bird on

the salmon and the strong pull of Little Turtle, White Fawn and Little Beaver on the line. After they had dragged the salmon far away from the water, the line pullers found that they couldn't let go of the line. It was some time before the laughter and the shouts started to come from five wet and muddy faces.

They cut a long branch and smoothed it for easy carrying. Then they pushed it through the gills of the salmon and lifted it from the ground. Nuk-Chuk was in front, then Talk Too Fast, then the salmon, then Small Beaver, then Little Turtle, and then White Fawn. With the branch on their shoulders, much of the salmon still stayed on the ground.

There were shouts as soon as the fishermen came to the edge of the village. But these shouts didn't come from four tired braves and one tired maiden. They had only grins on their faces as they marched into the village. The tail of the great salmon left a victory plume in the earth behind them and the sun bird was riding on the top of White Fawn's head where Nuk-Chuk had placed it very carefully.

Later, when Nuk-Chuk made his special mark for that day of the sun bird and the salmon, he put an image of the sun bird on the head of the image he made for the salmon. And to remind himself that this had been a *five person* salmon, he put five marks, like the rays of the sun, around the sun bird.

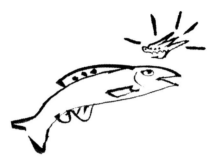

# 5. THE OLD ONE

Many questions were asked about the coming together of the old and the new, the blending that Mr. McPherson had been talking about. One day at school, Nuk-Chuk said to Mr. McPherson, "I have heard stories about gods, maybe wizards, who may be living in our mountains. If we should meet one, what do we say? Could we bring him into our blending?"

"You could say, 'How do you do, Mr. Wizard,'" Mr. McPherson said, and he could hardly find a straight face. Nuk-Chuk heard snickers, and a giggle, from the people around him. "For your second question, I would have to say that you would have to be very careful. If he was the kind of wizard who didn't want to be dragged into the twentieth century, you could find yourself looking like a toad...or even the long nosed one."

When Nuk-Chuk and the other students left for their homes that day, he saw that one of the others—very close to him—hopped like

37

a toad. And another—also very close to him—used his arms like a trunk on the end of his nose and he swung it back and forth as he walked. This made more snickers and giggles, also very close to him. These things gave Nuk-Chuk plenty to think about until the time when he could go to Topi.

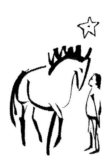

Topi was very hard to catch that day. Nuk-Chuk had taught him to come to his whistle, but the whistle wouldn't come loudly enough that afternoon. Perhaps the sun and the wind from the mountains and the forest voices had talked too much that day. Whatever the reason, Topi had to make his legs dance and his mane and tail fly in big circles around Nuk-Chuk. When he finally came to Nuk-Chuk, and he pushed his soft, black nose into Nuk-Chuk's face and belly, it was hard to be mad at Topi anymore. Very soon there were two who danced with the wind and bent the grasses and wild flowers, as they became brothers with the wonderful day.

They would go where the forest, the brooks, and the meadows would lead them. Nuk-Chuk's hands and legs knew the strength of Topi, but today he had no plans for this strength. Mostly he let Topi find the trail. Nuk-Chuk would bend his head to the neck of his brother and talk to him about falcons and silver fish and sun birds. Once they chased a rabbit. Then a deer

became a target that took them over logs and across a meadow covered by a robe of flowers. These two were proud of their strength together. So, when they saw a golden eagle hunting in the meadow, they challenged the eagle. Nuk-Chuk tried to match the cunning of his arms and legs with the leaps and turns of Topi, who was trying very hard to make wings of his feet. Soon it was no match and Nuk-Chuk became a bird for a little while before he made a hole in the flowers with his head. Topi came to him and Nuk-Chuk made him lie down in the flowers. There they watched the eagle laughing at them.

Then they followed the belly of the valley. It led them higher and higher until Nuk-Chuk could see only the smoke plumes from his village, and the Dragon was only a silver ribbon wrapped around the forest.

The sun became very strong, so they went into a forest near the top of the valley. Soon they came to a world Nuk-Chuk had never seen. The ferns grew as high as the head of a rider like him. When Topi plunged into the ferns, it seemed like he was swimming in a fern pool and Nuk-Chuk thought about fierce fern fish that might take him like the salmon had taken the sun bird. The soft patter of Topi's feet against the moss and pine needles, and the whispers of the breeze to the trees, helped to bring him back to truth. The trunks of the trees climbed higher than he had ever seen and they held up a roof of boughs that left little room for the sky. The sun came to them like spears of light and they used these spears to find a path through the forest. It would be Topi, and then it would be Nuk-Chuk, who decided which way to go from spear to spear. After they had conquered many log traps and vine snares, they came to a door in the forest and they went out to another meadow at the foot

of a great rock cliff. It was good to feel the sun again, and both of them rolled in the meadow to shake off the darkness of the forest.

High above the meadow there was a blackness in the rock. Great slabs of stone around the blackness made it look like the doorway to the castle of a rock god. Somehow these special rocks reminded him of the long-nosed one, and he started to climb toward them. When he finally reached the stone slabs near the darkness, his arms and legs showed many places where he had lost little battles to the rocks, and his chest fought to bring the air to him. He looked down and he could see Topi in the meadow. He was glad that he didn't need a whistle because he couldn't find one at that time.

When his breath came easier, he could feel a breeze coming from the blackness in the rocks. When his eyes got larger, he could see that he stood at the mouth of a tunnel going into the rocks. Slabs of rock, some as smooth as the blackboard at school, were at the sides and the roof of the tunnel. There were marks on the rocks like some they had seen on the body of the long-nosed one. As he walked into the mountain, he saw more of the strange marks. He saw carvings that he knew had not come from water or the wind. The path went upward, and the roof of the tunnel went away from him until he found himself in a great room.

When his eyes became like the owl's, he could see carvings everywhere he looked. There were some of the long-nosed one and some of beasts that the sandcastle hadn't shown them. He saw these things, and he also tried to see an end to the shadows that were now starting to bring some fear to him. The sound

of his moccasins against the sand floor and the whispering of the air with the images were all he could hear. He was alone with the powerful strangeness and suddenly he wished that he could be in the meadow with Topi, where there was sunlight and friendlier whispers.

When he tried to find the tunnel that had led him to this place, the shadows seemed to laugh at him and they took his feet in circles. This gave more food for his fear, and he knew that if he ever escaped from this strange darkness, he would never hide from the sun again. Then the words of his father and grandfather came to him. They told him to listen to the truths in his head when a trail is lost. These words stopped his walking and brought him to his knees on the sand. His chin came to rest on his chest as he closed his eyes and tried to listen to his truths.

He didn't see the spear of light that struck the sand around him. He didn't hear the sound of other moccasins against the sand, but he heard the voice that broke the silence of the rocks and made his heart leap against his chest. Then he felt the strong hand that made him stand up.

"Nuk-Chuk, it is good that you did not forget the wisdom of your father and grandfather. Soon, you would have found the footprints that could take you back to the sun. But you have come far, and I have food for a young belly that must have much hunger."

Nuk-Chuk looked up at a very tall man. He was dressed in the skins and robes of a chief. His hair fell down in two white fountains about a face that held more sternness and proudness than Nuk-Chuk had ever seen. The eyes of this face danced with the spear of light and then the smile of the Old One took away all of Nuk-Chuk's fear and left only an open mouth—and the biggest eyes in the world. He couldn't find any words as he followed the Old One into the light and through a door in the rock.

"Welcome to my lodge, Nuk-Chuk." The Old One opened his arms wide.

This new room was also very large, but there were oil lamps against the walls that made a soft golden light that took away most of the darkness. There were some shadows here, but they danced around the room and could bring no fear. Nuk-Chuk's eyes were filled with carvings and rugs and blankets and furs and weapons and thin skins with strange writing marks on them. When his eyes finally came back to the Old One, they were brighter than they had ever been. Finally he found some words:

"How did you know me? How did you know that I had come? How..." The stream of his words splashed the ears of the Old One. It was finally stopped by a raised hand and a smile on the old face that was made larger by the wonder in a young face.

"I have known you since your mother first smiled because of you. I could see you and Topi race the eagle. I saw you hold the sun bird to the sky." These words brought more wonder to a bowl that was already overflowing.

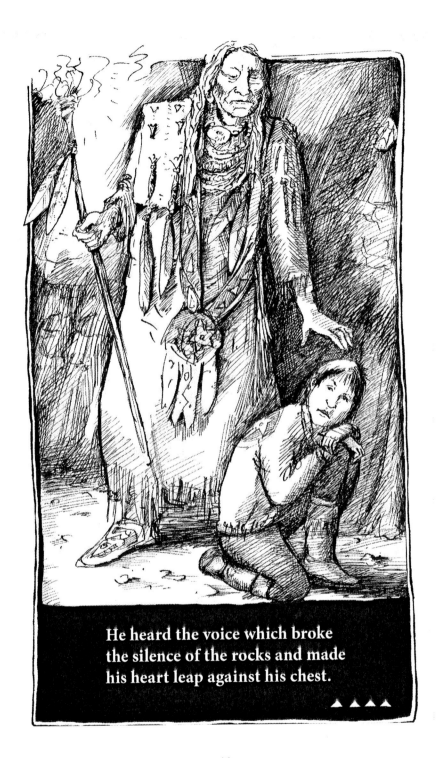

He heard the voice which broke
the silence of the rocks and made
his heart leap against his chest.

▲ ▲ ▲ ▲

"Topi will look for me...and he may find harm in the rocks," Nuk-Chuk said.

"He will be in the meadow when you are ready for him." The Old One's soft words made Nuk-Chuk know the truth of them. Nuk-Chuk sat on a thick rug made of black bear fur and he ate much of the berries and the meat the Old One brought him. And there was cool water from a cup that had been made from the ivory of the long-nosed one. Food and drink went into this mouth. Out of it came questions...about the carvings and the skins with the writing marks, about the weapons tipped with black crystal, about the sunlight that came from places in the rock. The Old One found answers when he could trap a question long enough. After Nuk-Chuk's hunger had gone, and the stream of his questions had run to a trickle, the Old One made his own questions. Nuk-Chuk told him about White Fawn and Talk Too Fast and Mr. McPherson and his other friends. And much more...the silver fish and the treasures of the sandcastle. The Old One probably already knew all about these things, but Nuk-Chuk *had* to talk about them.

Several times during this talk, Nuk-Chuk thought he heard a rumbling sound like the biggest dogs in the village could make. And he thought he could see a dog shape slipping in and out of the dancing shadows...with eyes that sent back the light like the red coals in his father's fire pit.

Finally, the Old One said, "It grows late, Nuk-Chuk. You will need a good guide to find the best trail back to your village."

Nuk-Chuk thought about the place where the shadows didn't dance, and about the fern fish and the vine snares in the place of the forest giants, where now there would be no spears of light to guide him and Topi. He was very glad to hear these words from the Old One.

The Old One spoke one word, "*Keena*", very softly. Then Nuk-Chuk heard the rumbling dog sound again and he saw a great dog shape rise from a place that had hidden from the lamplight. As the white shape walked toward them, Nuk-Chuk could see eyes that were like fire coals and he saw teeth that no dog ever had. He felt his breath catch in his throat as the wolf came closer, its ears cocked to trap the smallest word of its master. The soft black nose at the tip of the great white head was very close to him now and only when this nose touched the Old One's hand did Nuk-Chuk let out some of his breath.

"Keena…this is my friend, Nuk-Chuk. You will be his eyes for a little while." With these words, the Old One placed Nuk-Chuk's right hand on the wolf's head. Nuk-Chuk had to force his eyes to meet the eyes of Keena. When he did this, he was very glad to see some of the lamplight that now came, not as fire coals, but as soft golden light. He placed his left hand under Keena's chin and he rubbed the soft fur there. He heard the rumble of the wolf sound again, but when he looked into Keena's eyes again he saw only himself…and he was smiling.

The Old One gave Nuk-Chuk a belt made of white deerskin that had some beads of the black crystal, and a clasp of ivory carved like the head of a hunter bird. The Old One strapped the belt on Nuk-Chuk as he said the words of goodbye.

"We will meet again, Nuk-Chuk. Perhaps we will study the writing marks and listen to the stories of the carvings." Nuk-Chuk knew that he would come to this lodge again.

Topi came quickly this time to Nuk-Chuk's very good whistle. Many times during the ride back to the village, Nuk-Chuk spoke to his brother about the rock castle and the Old One who knew much about Topi.

Keena trotted swiftly in front of them and he found a trail that made the forest pass quickly. When they came to the valley that held the village in its belly, Keena stopped. His eyes flashed the fire of the sunset to them and then he was gone…just like the ghost that Nuk-Chuk *knew* he was.

Nuk-Chuk was late to dinner that evening and there was talk about this from his mother and father. His grandfather said nothing. He looked at Nuk-Chuk's new belt, and then at the eyes that still held much of the Old One. When Nuk-Chuk tried to talk about what he had seen that day, his grandfather knew that a trail may have been lost, but an old chief—and maybe a new chief—had been found.

After Nuk-Chuk had stepped into sleep that night, anyone looking at his face knew that the wizard he had found that day was going to be very good for him…and also for that blending business.

# 6. The Wolf, Keena

The salmon sheds were filled with racks of the silvery fish. Grain bins were groaning under the weight of the harvest. The small mountains of apples were everywhere and made bulges in mouths and bellies, some of which were called Nuk-Chuk and his friends. The big work of the fall season was over. Now it was the time to look at the rainbow that the trees had pulled from the sky and to run the pheasant and the grouse from their secret places and make them fill the air with their feathers and voices. There were new trails to find in the forest and across the meadows and the plains. These trails could show many faces of the Land to young heads with eyes to see the smallest jewel on the morning grass and ears to hear the softest whispers that the air could carry.

"Your pack will bring your pony to its knees with its weight," Nuk-Chuk said to Swift Elk.

"If the pack can't do this, then surely the great apple belly of Swift Elk will do it," Little Beaver said to Nuk-Chuk.

"My pony will carry *my* pack and *my* belly farther—and faster—than your cows will carry the burden of your mouths," Swift Elk said. His teeth were close together, and he pulled so hard on his cinch strap that his pony tried to bite the big apple belly.

Finally, Nuk-Chuk, Swift Elk and Little Beaver were ready to hunt for new trails. The little wind that had found them talked to these braves about cool fern pools in the forest and spring pools in the meadows. The pony of Swift Elk danced a little more than the other ponies. The pack of Swift Elk was a little heavier than the other packs. So, the pack of Swift Elk came down to the ground with a big noise.

"Ah…now the pony of Swift Elk can find strength for our trail," Nuk-Chuk said to Little Beaver.

"He will be our pack horse for the treasures we find," Little Beaver said.

"He will pack only Swift Elk and the treasures of Swift Elk, and he will find strength enough to share with your cows." After Swift Elk said this, he started to rebuild his pack and he tried to shut his eyes and ears from the other big mouths. Near the end of his work, four more big eyes and two not so big mouths watched and talked about Swift Elk's work.

"Is *this* a brave who would run with eagles and look for forest gods?" White Fawn asked anyone.

"We hope that he will find only gods who run with field mice and use them for ponies," Dawn Light said to anyone.

"*These* ponies will soon take us far away from the giggles of baby women," Swift Elk said.  His teeth were close together again and he tried to hurry his work.

"Hurry, Swift Elk!  The wind from these girl faces blows into the forest.  It will give wings to our ponies' feet," Little Beaver said.

"Are your mothers' apple piles so small that they can't fill your mouths...and their soft skins so few that they can't find work for your hands?" Nuk-Chuk asked these maidens.

"...Are your ponies so weak that they can't carry two who have been taught the secrets of the morning and evening fires... and the laying of soft bough beds?"  White Fawn asked these braves.

"...And the bringing of cool water...and...." Dawn Light tried to make her question bigger.

"And the two bellies that would add to the work of our hunts and the burden of our packs," Swift Elk said.

"Fresh bread from my mother's oven wouldn't make your ponies cry," White Fawn said.

"My father's jerky is the best in the village," Dawn Light said.

The bellies of Nuk-Chuk, Swift Elk and Little Beaver couldn't argue with these things.

"Your mothers wouldn't let their little pigeons go from the nest," Little Beaver said. But he hoped that they would because there was no better food than good jerky and fresh bread.

"They have given us packs of bread and jerky," White Fawn and Dawn Light said, almost together. The bright eyes of these maidens told that they could leave the nest for awhile if good braves would protect them.

There was some grumbling from the braves as they tried to find places on the ponies for the things of White Fawn and Dawn Light. When the smell of fresh bread crept out of one of the big pouches, the grumbling got very small and then stopped.

White Fawn held tightly to Nuk-Chuk as Topi took them swiftly to a door in the forest. Then she held very tightly when the arms of the giants brushed them at the door and Topi plunged into a cool green world where big shadows fought with spears from the sun. Nuk-Chuk felt White Fawn's hands tighten around his middle and her head press close to his neck as this forest world started to swallow them. He sent back a laugh to her, and told her that the fern fish that lived in that place probably didn't like girls. He also told her about the traps and the snares that the giants hid in the shadows. The ponies of Swift Elk and Little Beaver followed close behind Topi as they pulled a tail of shouts and laughter through the legs of the giants. Dawn Light rode behind Swift Elk and the talk about fern fish made another maiden hold tightly to another brave.

Topi and Nuk-Chuk found a good trail. Soon the three-horse caterpillar leaped from the forest into a meadow that was all sunlight and grasses bending to the mountain wind. They

stopped at a spring brook. While the ponies grazed, the riders buried their heads in the water. Then they chased silver and gold trout over the sand beds. When all the fish had hidden, they chased each other and it was in and out of the water for them, with much laughter tangled with everyone. Then it became the best quiet that the meadow and the forest and the brook could give. They all lay in the grass and watched a falcon play in the sky, and they told of faces they could see in the clouds.

They made their first camp at the head of another meadow where there was a clump of trees and a small spring. White Fawn and Dawn Light were quick in their work of gathering wood for the fire and the laying of bough beds. Besides the jerky and the fresh bread, their packs held other treasures for hungry bellies which the braves hadn't heard about. After they buried the cooking fire, they watched the jewels coming into the sky of the young night.

The cool river of air washed their heads and made them come closer to their blankets. It also brought them the voices of night birds and other sounds they didn't know. Then there was the wolf sound.

It came to Nuk-Chuk first…like the time when he walked away from the marking tree…and the little hairs on the back of his neck knew that sound even before his ears knew it. Then it came to all of them, floating on the currents of the night, and even the owl's voice was still because of it.

"Keena," Nuk-Chuk said to himself. But the other ears had caught his voice and four pairs of very big eyes looked from the sleeping places toward Nuk-Chuk. The wolf sound came again and now no blanket was thick enough to shut it from their ears. Nuk-Chuk stood and tried to pierce the night with his eyes. "Keena," he said again, like a whisper, and then he called this name into the night…but there was no answer. Soon there were many questions from the others. He told them about the Old One and the castle in the mountain and the great white wolf that had found a friendly trail for him and Topi. The voice of Keena didn't come anymore that night, but it was a *long* time before sleep could take him away from Nuk-Chuk and the others who shared his lodge under the sky.

The light of the new day woke Nuk-Chuk. When he splashed cold water into faces that didn't want to give up their warm castles, there was some talk—then some loud talk and a little shouting. After the plume of their morning fire had walked into the forest and they had buried its embers, the great pony with twelve legs and eight heads left the meadow.

They climbed to new forests and other meadows. Finally, they were at the edge of the great plains. Here the grass rose higher than the belly of a pony and the wind made waves in it that rolled to the end of the world.

"Look! Look! Buffalo!" one of the heads shouted. The other heads could also see the black shapes far out on the plain. The ponies snorted and reared and wanted to run toward them, but

the riders remembered the words of their parents: black spots like these can become very large and very fierce. The plain also showed them the white flags of antelope, and they laughed at the leaps and runs that could take away the flags so fast. They chased the ears of jackrabbits into waves of grass and they made pheasants and clouds of quail fly in front of them. They raced these things and then they raced each other. White Fawn and Dawn Light loved such a noise of wind and the power of pony gods like these. Their little fears had been thrown from the ponies' backs long ago. Now there were only their shouts that seemed to feed the ponies' strength.

The ocean of the plain pulled them far from the forest they knew, and its waves had covered the marks of their trail. When they stopped to rest, the sun was high, and there was no cool place where they could hide from the heat that poured from the sky. They were no trail guides in the sea of grass that held them, and the blue sky above them held only one cloud.

This cloud was different from any they had ever seen. It was like a great brown curtain falling to the plain. It came closer, and along the bottom of it they could see images like angry stallions of red and yellow which seemed to fight with the grass and feed on the wind. Then the wind brought them a sudden heat…and they looked into the face of the plains fire.

"We must run away from it!" Nuk-Chuk shouted. "Keep the ponies together and their faces away from the fire!"

He tried to find a path that would not take them deeper into the ocean of grass. The wind was very strong now and it wasn't made by the ponies' feet. It brought arrows of smoke and tears to their eyes. The braves had to fight very hard to keep the ponies' eyes away from the flames…whose feet seemed swifter than the ponies'.

Nuk-Chuk guided Topi toward a part of the sky that hadn't been eaten by the fire cloud. But very soon there was no more blue guide for them, only great hot ribbons of brown and white and yellow and tall grass that cried against the wind. Somehow, Nuk-Chuk kept the ponies together and he shouted brave words that sometimes only White Fawn could hear. Her face was pressed closely to Nuk-Chuk's back to shut out the tongues of smoke and heat that licked at them. Her arms and legs were pulled by the swift turns and leaps of Topi, as he tried to obey Nuk-Chuk's commands. The ponies screamed at the fire stallions and the ribbons of smoke became a blanket that almost put out the sun.

Nuk-Chuk prayed for the strength and wisdom of a chief. Then, he heard Keena's voice above the sounds of the fire.

Suddenly, there was the great, white dog shape beside Topi and Nuk-Chuk looked into eyes that had been born in another fire. Keena ran in front of Topi and Nuk-Chuk shouted for the others to follow. They could barely see and hear him and Topi. Several times Nuk-Chuk couldn't find Keena, and then Keena would come again and show the trail to them.

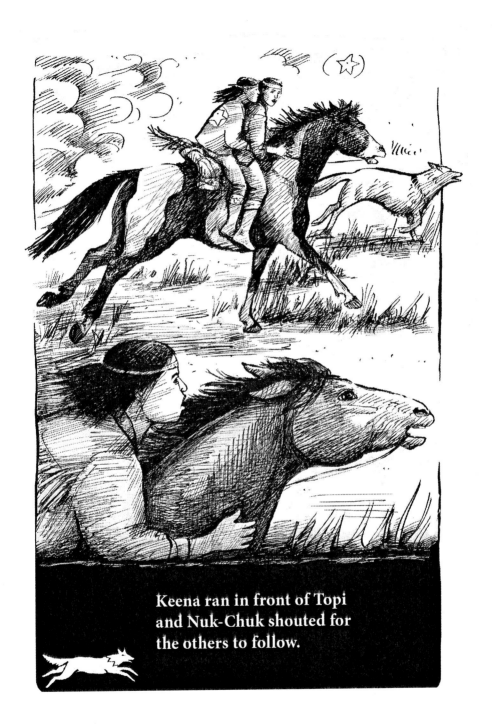

Keena ran in front of Topi
and Nuk-Chuk shouted for
the others to follow.

It was a long time before the smoke blanket became ribbons again, then the ribbons vanished into a bright blue sky, and their heads were washed by a cool fountain of air that hadn't tasted the fire. Keena took them to the edge of the plain and then he made them go far beyond the tall grass that was food for the fire.

Nuk-Chuk leaped from Topi and ran to Keena. The wolf let Nuk-Chuk's arms and mouth give him thanks. Only a small rumble came from the big white chest that had rested on rainbow rugs inside a mountain. The others also ran to Keena and he let them cover his body with hands and more kisses. Already the braves and maidens had forgotten the fear from the fire. Now they remembered mostly the good parts of a day that had brought them a new friend.

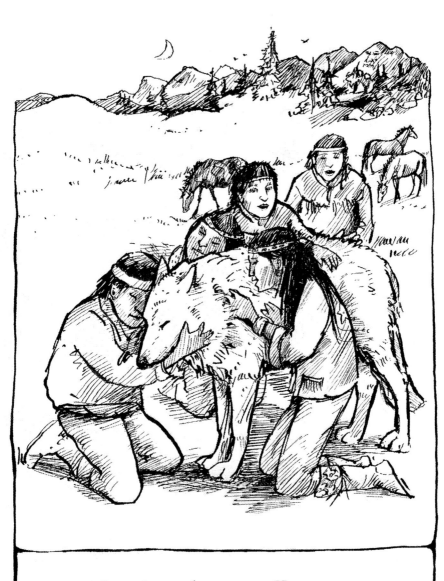

The others also ran to Keena.
He let them cover his body with
hands and more kisses.

Keena seemed like he was the strength—and sometimes the eyes—of the Old One. So, when Nuk-Chuk came to his private place again to do a special mark, he made only the image of Keena. When he looked at this new mark, the shadows around him danced like other shadows had danced in the lodge of the Old One. As he walked away from the grotto, there were more voices in the whispers than he had ever heard. Also, there was a rumble in there…just like Keena's.

# 7. THE EAGLE, NUFTI

It was now the springtime, and the furrow made by his father's plow seemed to have no end. When Nuk-Chuk came to the edge of the field, he looked back. He could see some of the places where he had put corn seeds into the earth. The pack that held his seeds felt lighter. Then he looked at a furrow he hadn't walked. It looked like a long snake that he would have to fight in many places. His pack felt heavy again.

When he worked his father's fields, he was doing some of that blending that they had been talking about in school. In the old times, the People moved their lodges to follow the fish and the sea animals. Or they went to the places of the buffalo, or to the high meadows for the special roots and berries that were good for eating or for making the rainbow colors for their blankets and clothes. Now, the lodges stayed in one place and the People were reaching more and more for the new ways that made it good to do this staying. He looked back again along the trail he had walked. The prints of his moccasins were in the soft earth,

59

and they seemed to come from very far away. He thought about the long trail that the People had taken to bring his moccasins to this place, this land of his father.

He had conquered may long snakes since the sun had driven the morning wetness from the field. Now there was a little time for pushing his head and arms into the brook near the field. He let the cool fingers of the water take away the heat of the sun, and also some of the earth that had walked with him along the furrows. Very soon he decided that the water was too good to keep from the rest of his body.

After his bath in the brook, he crawled into the sunlight that poured down on a sand bed near the water. He had planted many seeds that day. The bed he had found was soft. The blanket that covered him was woven of warm breezes, and they talked to him about sleep.

"The pack of this brave grows too heavy for him," his father's voice said, with a little frown in it.

"It is a pack that has given many seeds to the earth," his grandfather's voice said, with a little smile in his voice.

His father's moccasin stepped lightly on the head that had forgotten the long snakes of the field and now dreamed of antelope swimming in an ocean of grass and sun birds and ponies, especially a pony made of black and white.

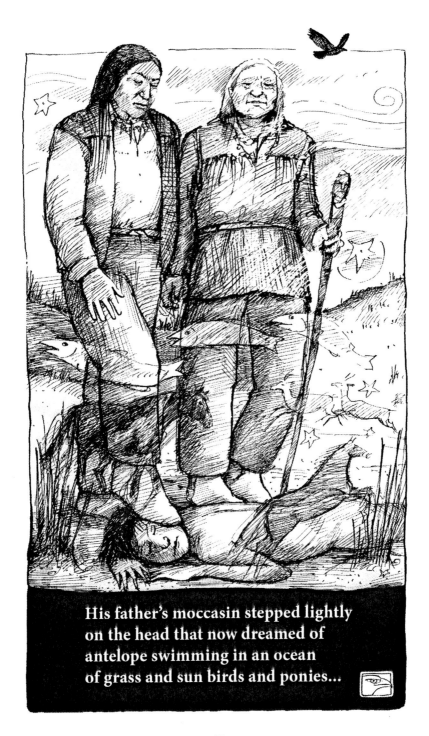

His father's moccasin stepped lightly
on the head that now dreamed of
antelope swimming in an ocean
of grass and sun birds and ponies...

61

The moccasin pushed a little harder. Nuk-Chuk opened his eyes. He looked up at two tall figures that were black against the sun. He couldn't see that one of them smiled, and the other one didn't...but he knew the moccasin that pushed his nose, and he used only a small smile to fight it. There was more talk about little braves who hide in brooks from the fierce worms and beetles of the fields. When the foot let him up, Nuk-Chuk was very busy finding his clothes and his seed pack. The pack felt much lighter now.

"It has been a long day and even the sun grows tired," his grandfather said, looking at the place where the sun was going to its bed.

His father lifted the seed pack. "You have lost many seeds from this pack. The crows will sleep with full bellies tonight." The voice was stern, but a great wink flew from his father to his grandfather.

"The crows will need feet like the badger's to find the seeds that I've lost in the furrows," Nuk-Chuk replied. His words made enough smiles for two faces...finally three faces.

Then a voice came to them from the sky. Three faces, still wearing their smiles, turned toward the bowl of the sky that the sun was painting with red and gold. The voice came again. Then they saw the great bird shape, floating in the ocean of the young night. The feathers at the edges of the wings and the tail caught little arrows of sunlight and made the breath come quicker to all of them.

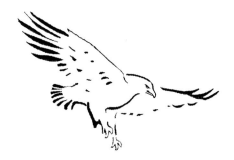

As Nuk-Chuk looked at this true bird of the sun, his breath caught in his throat just like it had done when Keena first walked toward him. The eagle's voice needed no help from the wind to come to them. It brought little prickles to Nuk-Chuk's neck, and he had to think of Keena again, but the eagle also brought some sadness, which Keena hadn't done. It came from a place where he could never travel.

"The crows will push their bellies far into the trees tonight," his father said, his eyes filled with the eagle.

"…And the rabbits will dance very softly in the moonlight," his grandfather said. His eyes were still aimed at the sky, and he was thinking about other eagles he had known, and about some men he had known who were brothers of the eagle.

"Can he see us?" Nuk-Chuk asked.

"He can count the hairs on your head," his father said, turning to the young brave who would know more about eagles.

"I wish I could come closer to him," the young brave said with a small voice. His eyes couldn't leave the great wings that were served by the currents in the sky and now looked golden when they laughed at the sleepy sun.

"To come closer to him is a work that you must be strong enough to do…and he must allow," his grandfather said, placing his right hand on the head whose eyes were still bound to the sky.

"A brave with the eye of an eagle, riding a horse as fast as the eagle, could find his home," his father said. He didn't smile, and his words were spoken like one who had just asked the breezes to search for somebody who could make a race with the eagle.

"…A brave is needed who wouldn't run from battles with rock cliffs and tall trees. One who could match the eagle's heart and talk to him about friendship." His grandfather's words were soft because they didn't have to travel very far to find such a brave.

"The belly of the field is nearly full," his father said. "Tomorrow will be a good day for running with eagles instead of furrows."

Nuk-Chuk couldn't argue with his father's decision.

The day was very young when Nuk-Chuk and Topi came to the field of the long snakes. They searched the sky for wings that could catch the sunlight before it struck the ground, but they found no wings like these. Another sun was born before they heard the voice from the ocean above them. For half the day, they watched the eagle hunt and play. It was very hard to tell Topi that it was not yet time to make wings of his feet. Finally, it was the time. They raced the golden wings across the valley, along the sand beds of the Dragon, and up to the feet of the mountains.

"Now I must go alone," Nuk-Chuk said to Topi, when the rocks started to laugh at the horse who would be an eagle. When Nuk-Chuk got down from Topi, he put his face and arms against the neck of his brother. Then he started to climb toward the wings that had found their castle in the rocks far above him.

At first, the rocks smiled at this young hunter of eagles. They let him move swiftly between them and through the brush and trees, but very soon Nuk-Chuk came to sterner faces in the rocks. When he tried to move too quickly, they tripped him with snares of vines and little rocks that rolled under his feet. They also took little patches of his skin and some of his blood as part payment for this journey toward the sky. Finally, he came to the very pillars of the mountain. When they saw this hunter of their secrets, they took the paths away from him, and they made him search for places where his legs and arms and fingers could push and pull him toward the eagle. He couldn't look down to where Topi was waiting. He had to look up. An eagle was there...and it was also waiting.

When there didn't seem to be any more places for his fingers or his feet, he pushed his face into the rock. As the wind tried to pull him away from the mountain, he remembered the words of his father and grandfather about eagle hunters. These words fed his strength, and he found more steps. His chest fought to bring the air to him.

Finally, his fingers found an end to the wall of rocks and he ordered his legs and arms to let him reach a place of rest. They obeyed, and he crawled into a little cave. The thanks he gave to his arms and legs were the loudest sounds in the world as he stretched them against the cool smooth bed of the cave. He thought about the battle that was behind him and he tried not to think about the one that was ahead of him. Little threads of sleep were in the cave and they wove a cap for him. He wore it for awhile.

A voice woke him. It wasn't the wind. He thought he dreamed about the sky above the long snakes. The voice came again and it brought him out of the cave to the face of the mountain. Then there were other sounds like he had heard when mother birds try to stuff little bellies. He crawled along a flat place in the rocks. Then, where no tree had ever lived, he saw branches and pieces of bark on the rocks. Farther on, a big pile of these things hid the rocks. It couldn't hide great wings that the eagle hadn't yet taken from the air. Nuk-Chuk dared to move only the parts of him that he needed for breathing. The eagle raised

its head from the nest and Nuk-Chuk thought that he had been pierced by two eyes that can send fear from high in the skies, eyes that knew secrets hidden even from the Old Ones. When the eagle turned its head back to the nest, Nuk-Chuk's heart went back to its nest and his breath came easier.

When he was brave enough to lift his head very slowly, he could see other wings in the nest. They were young wings and they were playing with children of the wind who had found them and were trying to coax the eaglets into the playground beyond the nest. Nuk-Chuk counted two eaglets. Then he had to hide his head quickly when the eagle tried to teach the eaglets the reason for feathers and wings.

One of the eaglets was a better student than the other. He pulled himself a little way into the sky with a great flapping of his wings, and then he landed on the edge of the nest, bending to the currents of air that washed his feathers. Nuk-Chuk was jealous of this first step into an ocean he could never travel. Then the young voyager grew more bold. He rose again and this time he got so high that the wind children took him away from the face of the mountain. They tossed and tumbled him in their playground. For a time, this eaglet knew fear. He beat his wings and cried against the wind, but soon he learned the reason for wings. Then Nuk-Chuk heard another voice from the sky that had more pride than fear in it, and he sent some of his heart to this eaglet.

The other eaglet was watching his brother. He saw wings that now made dives and turns and climbed to find new places in the sky. He could do this, too. His mother had told him so. He beat his wings and took a little step into the ocean of air; then

he fell back into the nest. Again he climbed. This time he could feel the hands of the earth falling away from him, but he was not yet ready for the playground beyond the nest. Even so, the wind children took him and he forgot his lesson about wings. The fingers of the earth pulled him against the wall of rocks and he fell away from the sky. Nuk-Chuk stood up when he saw this. He couldn't hide any longer and his voice cried with that of the eagle's. When he looked down the wall of rocks, he saw a little pile of feathers on a flat place far below him. These feathers moved only because of the wind.

He would never know how his hands and feet found the steps that took him to that place far below him. He only knew that, when he finally held the bundle of feathers close to his body, the shadow of great wings passed over him. So close were these wings that they moved the air against his face.

He found a little life inside the bundle, so he made a pouch for it with the upper part of his clothing. Then he took it down the mountain. Perhaps the rocks were friendlier now. Perhaps his head and body were stronger now because two hearts beat against his chest. When he reached the bottom of the cliff, he called to Topi and Topi came quickly. Nuk-Chuk had fed a life with his own life. When he showed the bundle of feathers to Topi, Topi seemed to understand this, and on the way back to the village, he made pillows of his feet for Nuk-Chuk and the little bundle of feathers. A great bird shadow crossed their path many times before Nuk-Chuk saw the smoke plumes of his village. This shadow didn't leave until he had carried the bundle into his lodge.

"These wings will grow strong again... and they will fear nothing that is above the earth," his grandfather said, as his strong fingers traveled over every part of the bundle Nuk-Chuk had brought from the mountain. When he found the head, buried deep inside the feathers, these fingers rubbed the beak gently, and they passed over eyes that were still closed.

There were many eyes around that table where the bundle had been placed. Some were in faces that smiled. Some were in faces that tried very hard to smile. After the feathers had been stroked enough to make the outside of a proud eaglet, a soft bed of straw was made. Nuk-Chuk's mother *didn't* say that the bottom of his bed was not a place for eagles.

Nuk-Chuk gave the name, *Nufti*, to the eaglet. Nufti had to find strength very quickly if he was not to smother under the blanket of love that covered him in his new home. Nuk-Chuk found the most tender pieces of meat for Nufti, and many times this meat came from his own meal.

He made Nufti move his wings and legs. When the eyes could show some fierceness again, Nuk-Chuk taught Nufti to ride on his arm and they took long walks. These walks always ended

with much bragging when other eyes and fingers would test the beauty and strength of Nufti. He made a little harness that didn't trap Nufti's wings, and he fastened a long line to the harness like the kind he had used when his *other* sun bird had flown. Soon, Nufti learned the lesson of wings and he would try to pull the line into the sky. Nuk-Chuk would run with the line, and sometimes he made Nufti fly in big circles around him. Nuk-Chuk's shouts and laughter made Nufti do all the things for which wings are made.

Nufti also learned the lesson of friendship, and soon there was no need for the harness and the line. When he wasn't walking on the air, he would often ride on Nuk-Chuk's shoulder. Many times this shoulder would be riding on Topi. Then there would be three hearts that beat like an eagle's. Sometimes—when a great bird shadow came from the mountains and boasted to the wind about a young eagle and his two special brothers...there would be four of these hearts.

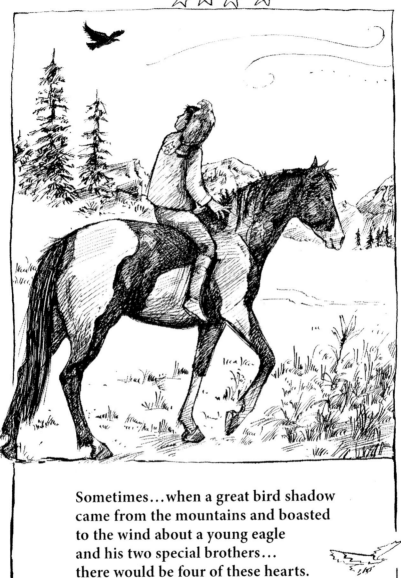

Sometimes…when a great bird shadow
came from the mountains and boasted
to the wind about a young eagle
and his two special brothers…
there would be four of these hearts.

The mark of Nufti was now the highest on the wall of his private place. He had put it just above another head mark his grandfather had made. The two head marks were separated by almost the width of a man's hand. For the second mark, his grandfather hadn't needed hardly any pushing to make it honest.

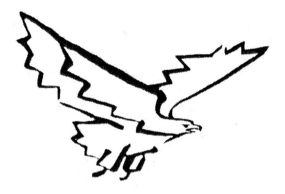

# 8. THE DRAGON RIDERS

When the forest trails, or the big secrets of the mountains, or the little secrets of the meadows called to Nuk-Chuk and his friends, there were ponies or their own legs to take them to these places. But when the voice of the Dragon called to them about white water that played with the sky and could catch a rainbow, or clouds of green and blue water that talked to salmon, then other feet were needed. Some called these feet *canoes*. This was a good word and the People sometimes used it. It told of a chair that went on the water, but a true brother of the Dragon needed his head and his arms and legs. Sometimes he needed all the strength that was in him. With these other things, the canoe *was* water feet. Without these things, it was only a chair fit to float on ponds and race the feet of ducks. With good *water feet*, and a paddle to make them move, there were very few parts of the Land that could hide from sharp eyes and strong hearts.

There were many braves and maidens in Nuk-Chuk's village who were younger than him. Because he could make good boats from bark and fish skins and the special pieces of wood that little hands could find and little legs could carry, Nuk-Chuk

was asked to make many of these boats. But it was very hard to catch Nuk-Chuk. If he and Topi weren't playing hunting and hiding games with Nufti, or the three of them weren't looking for secrets of the Land, then his head was always filled with other thoughts which kept him too busy to make little boats.

One day they caught him. His feet had stopped moving for a little while. He was trying to make bone hooks small enough, and sharp enough, to fill his mother's fish basket with trout. These were the ones that made circles when they danced in the lake, and they were silver and red arrows that flew around the brooks and in the pools of the Dragon...and they laughed at big hooks.

"Make it longer...and with a seat for my frog," one of these small voices said to Nuk-Chuk after he had been trapped by one of the little boats.

"Can you make mine wider so my turtle can ride in it?" another of these voices asked. There were many other orders and more questions. Some of the boats were made and many more were not. Nuk-Chuk prayed for more hands and more silence.

"The wind from your mouths will blow holes in these boats before they can find honor on the water," he said. He worked hard and didn't see the coming of bigger mouths toward the little boats.

74

"Ah...Nuk-Chuk makes mighty boats for frogs and turtles," the voice of Talk Too Fast said.

"Maybe the rain will bring puddles so he can find *some* honor racing the swift worms," a voice like Swift Elk's said.

"My canoe is big enough for *all* your boats, Nuk-Chuk. I'll carry them across the lake to a little island. There they can play with butterflies in oceans made by the tracks of moose feet," Little Beaver said.

There were more big words from these braves to splash Nuk-Chuk's ears. When he had finished the boat that was in his hands, he shooed the baby braves and maidens to places where frogs are chiefs. Then he tried to find some words for his own mouth.

"You should follow those babies and study their wisdom," he said to the faces around him. Most of these faces had big smiles which Nuk-Chuk's words hadn't taken away. "The canoe of Little Beaver is fit only for storing apples. It would cry if it faced the great oceans made by the moose feet." His smile was as big as any around him.

"Talk of great canoes and the braves to paddle them comes easily when we're far from the Dragon. Let's make a race that will show us the great ones," Talk Too Fast said.

Many more words flew between mouths and ears. When they stopped, a race with canoes was starting to be made. Little Bear and Little Turtle would also come to this race when they heard about it.

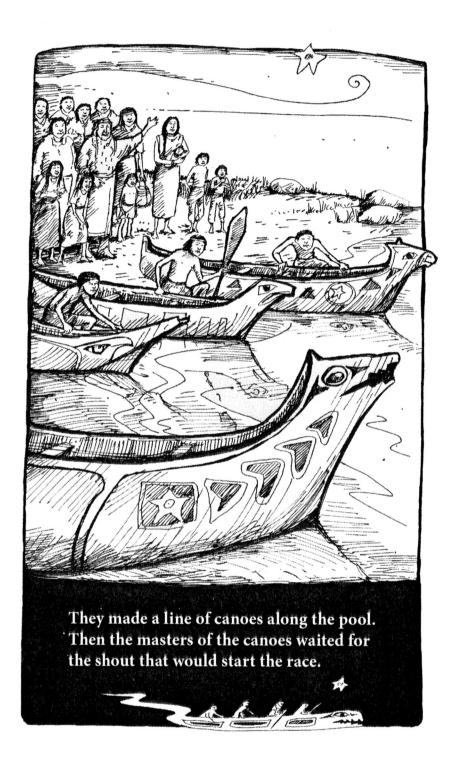

They made a line of canoes along the pool.
Then the masters of the canoes waited for
the shout that would start the race.

76

There was much work in the making of canoes lighter, or stronger, or smoother, or tighter against the water, or all of these things. For this work, they used some of the old materials: fish and animal skins, wood shaved as thin as they could make it. They also used some of the new materials: canvas, and some smelly stuff to cover it that was supposed to keep out the water. This stuff worked almost as well as the tars and resins the People had used for a thousand years. When they finished the bodies of the canoes, there was much painting with bright colors. Only when these colors showed fierce birds and animals on the heads of the canoes were they ready to be called *water feet* for the braves. They drew plans for the race on a sand bed of the Dragon, with their canoes crouching behind them like thirsty children of the Dragon who had dipped into the fire of the rainbow.

They would start the race at a great pool near the village. Then they would go through the place of the cliffs where the water was squeezed until it jumped into the sky. Then they would go out into the lake and to an island. The first brave to touch the head of his canoe to that island would be called *chief* of the Dragon riders.

They made a line of canoes along the pool. Then the masters of the canoes stood beside them and waited for the shout that would start the race. This shout was to come from the mouths of White Fawn and Dawn Light. When it finally came, it also came from the mouths of many younger and older ones who also stood near the canoes. This shout became a roar of yells

and screams and laughter that went across the pool and made a beaver hide his head and a falcon drop his fish. Most of this sound was for the braves who leaped into their canoes and pushed them swiftly far out on the pool, their paddles making a big whiteness on the water. Some of this sound—the part that was laughter—was for Little Turtle. When he leaped into his canoe, he forgot that feet must come *very* softly to the thin body of a canoe. Both of his feet went through the bottom of his canoe and he wore it like a dress of many colors. His feet stuck in the sand and his eyes and ears were splashed with the laughter. Little Turtle hoped that the sand would swallow him.

The canoes of Nuk-Chuk and Talk Too Fast and Swift Elk and Little Beaver and Little Bear plowed white furrows across the green body of the pool. When they reached the spot where the Dragon started to run through the cliffs, the watchers on the bank couldn't tell which canoe was the swiftest. The racers were so close together that they looked like a great water bug that had fallen into a dozen paint pots. Very soon, the bug plunged into the white and green storms of water at the place of the cliffs.

On the quiet pool, the braves had given proud orders to their water feet and they had been obeyed. When the Dragon started to run faster, the feet still obeyed, but there was not so much boasting in the shouts. When they were pulled into the white and green storm, the hands of the Dragon started to pull and

push the feet of the racers. At this time, the Dragon decided that this race could use some more excitement. So, it started to toss the riders into the air, and it bounced them against big walls of water just to see the splashes. Nuk-Chuk could hear only a roar of water sounds. He fought with his paddle against the hands that seemed to laugh at his strength, and these hands bounced him like he had bounced babies on a blanket.

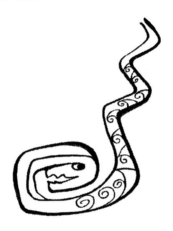

The trail he had found led him to the tops of great piles of water and it dropped him into dark green caves where he hoped he could find the sun again. He threw his voice to the Dragon and he shouted to his canoe and to his friends. Once, he saw another canoe flash its colors at him just before the green hands pulled it away. Once, he heard another voice challenging the Dragon, but he lost the voice when he came to where the cliffs hammered the Dragon into hissing white pieces and threw them down to the lake.

Nuk-Chuk tried to push back the great blanket of angry whiteness that was trying to drown him. But when his canoe dug its nose into the blanket, he lost his water feet and he started

to tumble down the water mountain toward the lake. Later, when he thought about this moment, it seemed like a dream where he was swimming in green and white clouds. When his head finally found the air again, he saw his canoe floating with its belly to the sky. He swam to it and, after a lot of splashing, he turned it right side up and crawled into it. The fish skins they had made into bladders had done just what his father had said they would do. They had kept his canoe away from the bottom of the lake. Of the other Dragon riders, only Little Beaver had also used these fish bladders under the seat of his canoe. Talk Too Fast had called them *frog bellies* and he had pulled some of the other braves into his laughter. Nuk-Chuk couldn't find his paddles, but he was very glad to rest inside the body of his canoe with the frog bellies.

The island, which was the end of the race, lay far out in the lake. Nuk-Chuk couldn't see any of the other canoes, but he knew that the water mountain would spit them out. And if they came with paddles, then he would shout, "*Chief!*" to another. He tried to make paddles of his arms and hands. In this way, a duck called Nuk-Chuk waddled toward the island.

Another head popped out of the lake, then another...and another. Then a canoe came tumbling down the mountain, then another head came up.

"Ho...Nuk-Chuk!" called the wet face named Talk Too Fast, when he stopped spitting water and taking great gulps of air.

"Ho...Talk Too Fast." answered the duck who waddled toward an island.

"Will our brother let our bones go to the bottom of the lake?" called the slippery face named Swift Elk. His canoe had already found that home on the bottom, and so had the canoes of Talk Too Fast and Little Bear. Among the newcomers, only the canoe of Little Beaver still clung to the bowl of the sky. Like Nuk-Chuk's had done, it floated like a turtle on its frog bellies, and it had also lost its paddles.

"The apple basket of Little Beaver will hold *all* your bones," Nuk-Chuk shouted back. "I'll go to the island with my duck and send butterflies to pull you. You may still find some honor in the oceans of the moose feet."

The basket of Little Beaver was finally turned over. Two braves got inside and two more stayed in the water and held the side of the basket. If Nuk-Chuk was a duck that waddled, then they were a goose that pushed its fat belly against the lake...and made much more noise than travel. The race that had started with five eagles, was ending with a duck and a goose.

Near the island, Nuk-Chuk stopped and waited for the goose. "Go, Nuk-Chuk," Talk Too Fast called, "before your duck dies from all this excitement."

"We will push the nose of only one canoe into the island," Nuk-Chuk answered.

And so it was. After they had come together, Nuk-Chuk left the duck and pushed from the back of the goose to help it get to the island. From the sands of the island, a loon heard five voices shouting "*Chief!*" to each other.

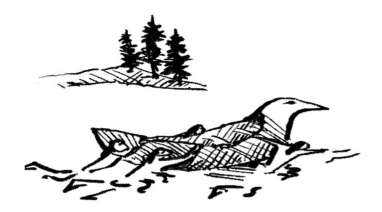

# 9. THE CRYSTAL GARDEN

"It was a big cave and we could feel the breath of cool air coming out of it…and hear water falling inside of it," Nuk-Chuk said to White Fawn and Dawn Light, whose eyes were getting very big.

"There were tracks of deer going into it. I thought I could hear sounds coming from it," Talk Too Fast said.

"Near its door, we found little pieces of crystal that showed rainbow colors when the sun came to them," Swift Elk said.

"Where is this place?" White Fawn and Dawn Light asked, almost like one voice. They couldn't keep their hands and feet from doing a little dance of excitement.

"…And there were flowers and vines that tried to weave a blanket to hide the door from us," Nuk-Chuk said. His voice and his eyes teased the maidens when he didn't make an answer for them.

The questions came again. This time they were louder, and they came with two sticks that started to chase the laughter of the braves.

"It is far away. It would take too much of your mothers' fresh bread—and your fathers' jerky—to give us strength for the journey," Nuk-Chuk said. Two sticks were very close to his head. His smile caught them just in time.

"Also we will need to borrow water feet," Swift Elk said with a little sadness, remembering that his canoe was now a bed for eels and fish.

"Little Beaver will let us use his apple basket," Nuk-Chuk said. "I made him a sun bird. It will catch water feet as well as salmon."

When the food pouches had been filled to overflowing, three braves and two maidens were ready to hunt for secrets.

They carried two canoes over a little portage to an arm of the lake near their village. The Dragon hadn't taken away all the colors from the canoes, so it was a terrible animal with two colored backs and ten legs that walked to the lake. This animal made some laughter for those who watched it. It also made a rabbit jump back into his lodge, and a hawk stop in his flight.

Dawn Light rode in Little Beaver's canoe with Talk Too Fast and Swift Elk. White Fawn made a very pretty scout at the head of Nuk-Chuk's canoe. This time, the journey to the island was as swift as true water feet, served by strong young backs and arms could make it. They called back and forth between the canoes,

their voices making now the sound of the loon, then a bull elk, and a goose, and a turkey. When these false voices weren't calling, there was true laughter that spilled over the sides of the canoes and left a shining trail on the lake.

The island came too soon. Actually, it wasn't quite an island, but a piece of the Land connected to the great wall of mountains by a thin backbone of a little mountain. They pulled the canoes over the sand beach and carried them far from the water. After they had made a cache for their food, they were ready to start their hunt for secrets.

"Near that tree...against the little mountain," Swift Elk said.

"No. We followed the water which came from a spring in the rocks over there," Talk Too Fast said, pointing to another place farther up the little mountain.

"We found it when we saw a deer swallowed by the rocks," Nuk-Chuk said, rubbing his head, trying to bring back the picture of a rock that could swallow a deer.

The braves had battled the Dragon the day this secret had been found. Empty bellies and tired bodies could have taken them to the door of a secret, but no farther. Soon, they forgot the picture their eyes had seen. Now, the vines were everywhere and the braves were pointing everywhere, trying to remember the picture.

"The air is very still," White Fawn said. "If we walked close to the little mountain...and *very* softly...maybe we could feel its breath." The braves couldn't argue with White Fawn's plan.

They made two searchers out of the three braves and the two maidens. These searchers walked in opposite directions, climbing up the little mountain. The searcher made of Nuk-Chuk and White Fawn walked for a long time, and they heard no voices except those of a raven and a hawk, and the laugh of a loon. They felt no breath except their own. When they came to a place where some flowers peeked from the vines, Nuk-Chuk made a little crown of the flowers for White Fawn. She found an owl's feather and placed it in his hair. There were no clouds to stop the sun and the fountain of its heat made the air heavy on their heads. Only the bees and the dragonflies wanted to swim in air like this and the whispers of their wings were the loudest sounds in the world.

Finally, they came to a big oak tree that held back the vines and let ferns and moss grow in its shade. Here, the silence came very easily, and the coolness was wonderful.

"The sun must be very hot to make this place seem so cool," White Fawn said, after they had rested for awhile. She couldn't stop a little shiver.

"I don't think the sun has done this," Nuk-Chuk said. He stood and then he walked around the tree, testing the air with his nose and putting his ears into the silence. When he came back, he brought a big smile and words of excitement. "We've found the secret!" he shouted. "I must find the others. Stay here until you hear my voice again." The moss bed, the gentle touch of the ferns—and the cool breath of the secret which didn't make her shiver anymore—wouldn't let White Fawn argue with Nuk-Chuk's orders.

White Fawn heard the rocks moving under feet and the vines moving under hands and feet before she heard the voices. There was no need for silence now. Suddenly her ears were splashed with shouts and she was pulled from her bed of moss by many hands. Dawn Light danced around the tree when she knew that the cool breath around it came from the secret.

They found some of the sticky stuff from pine trees that makes good torches when put on the ends of sticks. Talk Too Fast and Swift Elk and Nuk-Chuk made many of these torches. Now they needed only the heat from the little fire sticks they had brought, carefully wrapped in fish skin, to bring them light where there was no light.

A mighty hunter of secrets was needed now, and they made such a one. It had five pairs of eyes, five pairs of ears. Nuk-Chuk was the head of it. Swift Elk was the tail of it. If Talk Too Fast was the belly of it, then White Fawn was the front legs, and Dawn Light the back legs. The hunter pushed its head into the vines and entered the door into the little mountain.

The vines became a wall of green light behind them. There was a blackness in front of them and its breath was very cool. Soon, their eyes grew big enough to trap more of the light.

"It's a tunnel made of green rocks…and they sparkle!" White Fawn cried.

"It goes into the heart of the mountain," Swift Elk said, using a small voice.

"Hold tight to the light sticks," Nuk-Chuk said. "This light is good enough now, but soon even the owls couldn't use it…and *our* light will be needed."

They walked slowly along the tunnel, their feet rolling little pebbles over a bed of smooth rock. The rock walls took the sounds of their walking and talking and played with them. Sometimes it seemed like strange voices called to them from many places in the rocks. Sometimes, black holes in the rocks would trap their sounds and keep them from coming back at all. When they came to a bend in the trail, the light from the door almost left them.

"We will light two of the torches," Nuk-Chuk said, stepping back into the small piece of sunlight that would soon lose all of its courage.

"When we come to the forks in the trail, we should make little piles of rocks to mark our trail," Talk Too Fast said.

"Put your hands on the shoulders of the one in front of you," Swift Elk said.

"Let's keep our voices quiet so we can hear the mountain if it speaks to us," White Fawn said.

"I think I hear watersounds," Dawn Light said, almost like a whisper.

So plans were made for the hunter, and more excitement was found for the hunter, and it went deeper into the little mountain. The torches threw their shadows against the walls and the roof, and these shadows danced like demons as they traveled around

the rocks. The roof and one of the walls went away from them as they walked. Soon, there was no wall on one side, only a blackness that ate their torchlight, and the roof seemed like a black sky with clouds of stone that sparkled like stars.

"Lock your hands together," Nuk-Chuk said. "We are on a ledge above a place that would be happy to have our bones."

The watersounds were stronger now, and there was some mist that told of falling water. This mist made the rocks slippery. White Fawn gave a little scream just before Nuk-Chuk and Talk Too Fast's hands stopped her fall. The ledge gradually became wider, but there was more slipping—and even some crawling on hands and knees—before they reached a floor of sand that seemed like the bottom of the world, but up, or down, was very hard to tell inside this little mountain.

"Light more torches!" Nuk-Chuk ordered. Talk Too Fast and Swift Elk each brought one of their light sticks to Nuk-Chuk. There was a little hiss as the stuff of the pine caught some of the light in Nuk-Chuk's torch. Then there was a gasp from five throats as the bigger light defeated the darkness. It showed them a forest of giant crystals rising from the floor almost to the roof of a great room. This roof held more jewels than the sky of the true night. The torchlight was a stranger here and the crystals welcomed it with flashes of color and brightness that even the rainbow couldn't show. The hunter who had caught a

secret walked and ran among the crystal trees. Its torches made a dance of fireflies in the garden of a giant.

"Look! Look!" White Fawn exclaimed. She had filled her hands with some of the fine sand from the floor. As she let it go through her fingers, it made a fountain of tiny jewels that spilled over the tips of her moccasins. Some of the sound of her joy lost itself in the crystal forest…but a lot of it went to places that sent it back to her like the voice of tiny bells.

"Here is the water!" Talk Too Fast held his torch over a little brook that flowed through the rocks on the floor of the room. Everyone could see that even brooks wore jewels in this place. The water was sweet and very cold. It was good for throats that had made too much noise, and for feet that had battled the rocks.

"Here is more water…and more…and here!" Swift Elk shouted. As he took his torch to new places, the mirrors of many little pools flashed gold and silver lights. Some of these lights had been in the torch, and some of them had hidden in the crystals until the hunter had found them.

"Here is the *father* of the water" Nuk-Chuk called to the other parts of the hunter that had found the place where the mountain washed its treasure. He stood on a great block of crystal, and the torch he held high over his head spilled some of its light and made a shining gold altar for his feet. Some of his light was eaten by the blackness, but there was enough left to show a great spring pouring from the rocks far above them. The others ran to Nuk-Chuk. In the greater light they brought, they saw a waterfall that was like a great curtain. It was woven of silver

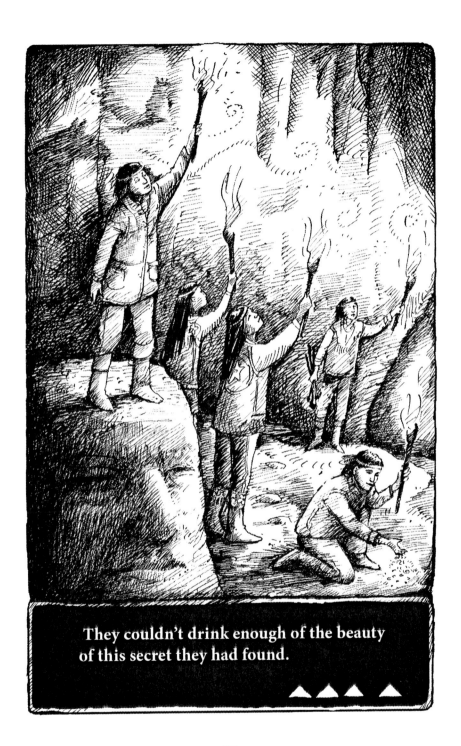

They couldn't drink enough of the beauty
of this secret they had found.

thread and it rippled against crystal columns in patterns of color that no rug or blanket had ever shown them.

They couldn't drink enough of the beauty of this secret they had found, but some of their torches were spent, and the others would soon follow them. It was time to leave for the world outside the mountain.

"I think we've gone more up than down getting here from the lake," Nuk-Chuk said. "This water must go to the lake. I wonder if it could show us a better trail out of here."

They had three torches left. Swift Elk kept one for a spare, and they used the two that were still burning to find a trail along the little river made by the waterfall. Sometimes, they had to walk in the water when the walls took away their trail. The torchlight would trick their eyes, and they slipped and stumbled. They even had to swim a little when their light made deep look like not so deep. Yet, it was a better trail and they were glad about this until they came to a place where the little river became a big pool. The torches showed five heads that looked at this pool, looked at the rock wall in front of them, and then looked at each other. It must be said that, at that time, some little fears were born in all of the heads.

"I think we are close to the lake," Nuk-Chuk said. His words were still bouncing from the faces in the rocks when first one torch, and then the other, flickered and died.

"My torch and my fire sticks are still dry," Swift Elk said in the darkness that had just covered them. "I'll go back to a dry place and light my torch. Then they heard the splashes of Swift Elk as he started to do what he had said.

Suddenly, Dawn Light shouted, "Look! Look at the end of the pool!" At first no one knew where to look. Then they all saw what Dawn Light saw. The end of the pool near the wall of rock held a pale green light. At one place, this light was almost as bright as a torch that could live in the water.

"It's the lake!" they all shouted, like one big voice.

"I will go and find the rest of our trail," Nuk-Chuk said. Swift Elk and Talk Too Fast argued a little with Nuk-Chuk, but before they could make many words, Nuk-Chuk had swum to the end of the pool. Then, with a little splash, he dove into the green light. His head popped up very soon. He told them that with a very long breath... and a little swimming like a fish...they could come to the lake again.

They decided that Swift Elk would be the last to go. Talk Too Fast would wait at the top of the lake for the heads to come up. Nuk-Chuk would take a very big breath and then he would wait in the green light until White Fawn and Dawn Light had been fish for a little while.

White Fawn and Dawn Light were very good fish. They made big smiles that pushed the water away when they came up to the sun again. Afterward, all of the hunter walked on the sands of the beach with much talk and laughter. Then the braves chased the maidens right up to their cache of food, which was now a very big treasure.

"I wish I could have had a necklace of the crystals," White Fawn said. She had used such a soft voice that there could have been some sadness in it.

"Like these?" Nuk-Chuk asked, and from a deerskin pouch he poured a little fountain of the rainbow into her hand.

Swift Elk and Talk Too Fast had also hidden some of the treasure in their pouches and pockets. "And these...and these," they said, as they poured more crystals into the maidens' hands.

The sun made bright jewels from the crystals they had seen by the torchlight, but the brightest jewels the braves found that day were in the eyes of two maidens who had helped them make a treasure hunter...and then a treasure finder.

# 10. TOPI, NUFTI, AND KEENA

The sun was starting to put colors into the bowl of the night. Soon, the owls and the foxes would be talking about trails that went back to their secret places.

Long before this time, Topi's eyes and ears and nose had been getting signals that came to him from a thousand places of the night. Some of these were a part of every night, and he was beginning to know them, but there were other signals made of things he didn't know…yet he *did* seem to know them. The little wind that moved the grasses and the sage in the soft light of *this* half day, half night whispered to him about memories that were old before the birth of the Old Ones. Some of these memories quickened Topi's strength and made him restless to match this strength with his own adventure.

The log fence of his corral was high enough to tell Topi that this was his home between the times that he shared with his brother, Nuk-Chuk. Mostly, it was good to have a place where he could rest and build new strength to match this crazy brother

who made hunts for secrets that sometimes needed even more than an eagle of horses could give. But this night had made a challenge to Topi's strength and this was adventure that he couldn't share with anyone.

Topi jumped the fence. In the world beyond, he moved his legs in a gathering of power he had never known before. The whispers of the air became shouts that he answered with his own voice and the small thunder of his feet. When a big leap took him away from the earth, there didn't seem to be enough room in his body for his spirit. So, he made his leaps longer, and his time with the earth shorter. Only now could he match his travel with his spirit. Surely, there could be no memory of a greater one like him.

Topi made his own trail. He plunged into dark shadows and climbed into soft gold light. His eyes filled with the wonder of the birth of that day, his head filled with the discovery of his strength and the honor of old memories. On the soft rugs of grass of the meadows, and the strips of living earth between the lodges of the sage, he found his greatest swiftness. He found his almost wings, which were legs. Where this one had passed, the ribbons of morning whiteness were left dancing. And there

were some, who had left their burrows to test the first parts of the new day, who would talk for a long time about the ghost made of black and white, traveling with the wind and carrying eyes filled with the morning fire.

He came to the body of the lake that held the crystal garden. Here, he stopped his running on a little table of rocks above the water. He raised his head to catch the smallest challenge of sight, or smell, or sound. A great chest pumped a river of air into him, and the cool breath of the lake turned his breath into white smoke when it left his nostrils.

The sun was playing with sheets of silver and gold on the great body of the lake. Only the track of a loon and the splash of a fish hawk could tell that the wonderful smoothness was made of water. For Topi's ears, there was the best silence he had ever known. But the loon finally had to make a laugh and this was a very big surprise for Topi. When the loon stole the silence, Topi leaped from the rocks into the shallows of the lake. From a big piece of the lake, he made a fountain of shining water beads. When the great laugher saw the terrible smasher of water, he pulled the lake over his head and left only black rings on a quietness of silver for Topi's eyes.

The cool water was good for feet that had carried the wind across the Land. Topi threw more fountains into the sunlight with

great kicks from front and back. Then he bent the tall reeds and water grasses as he made a crazy race along the shallows. He ploughed furrows in the water and threw his voice to the place where the lake had hidden the loon.

When he climbed from the lake to a finger that the Land had pushed into the water, he took a shining coat the lake had given him. He also wore a necklace made of the stems and flowers of water lilies.

The loon *could* have made a big laugh out of this, but another one, far across the lake, had also watched this play of the water smasher. This one's voice— like the sound of a saw cutting into the body of a whirlwind— killed the silence. It made a statue of Topi's body, and choked the throat of the loon. Some parts of the new voice were born again in the rock cliffs near the lake. Then, these were answered by another voice, like the first, but from a different place. There was silence again…but sleep had been taken from every lodge around the lake, and fear walked all of its trails.

The new voices were strangers to Topi's ears. They spoke of boastful challenge, of a strength to carry this challenge to any place of the Land where Topi could go. And like the swallow that flashes across a cliff of sandstone and then is gone, so did fear come to this one who had brought his own challenge to the lake. Perhaps the strangers had seen his swiftness. Perhaps

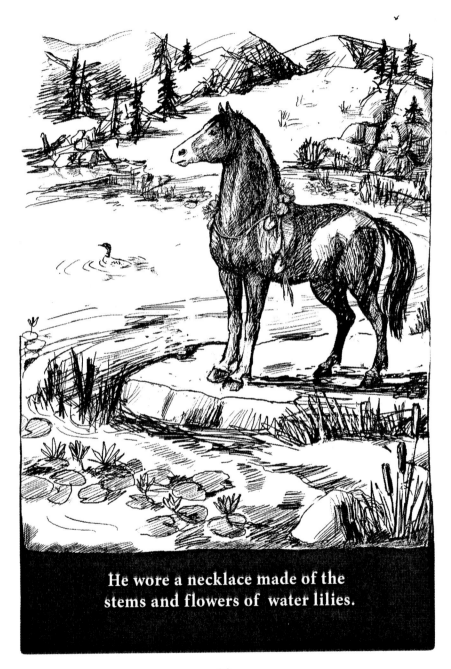

He wore a necklace made of the
stems and flowers of water lilies.

they had seen his strength pound the water into foam. And now, they wanted to test him in a game of racing that could eat big pieces of the Land. If this were true, then he would do this with them, and before he was done, he would pull the breath from the ones who had called him.

It *was* true that Topi had been called to a game. For the first time of his life, he had been called to a game of hunting by two *chiefs* of the hunters.

The voices of the challenge had come from a place where the forest stepped close to the lake. Here, the giants had dropped many big rocks on their way to build the mountains. When he was ready, he would go there, but for now, he pulled the heavy wetness from his body by a great running on the flat places near the shores of the lake. He didn't stop until the sun and the air that he had made into a wind had rubbed him dry and smooth as a deer. He almost forgot the calls to the game. When the voice of Nufti spoke to him from far above, he could think of nothing but this other brother who had also heard the whispers of that morning.

Nufti had also been a hunter of a horse that had come too far, alone. On his soft trail, made mostly of the breath of the night, Nufti had moved silently in great circles. He had kept hunting until he finally saw his brother who had pounded some thunder into the Land.

Topi looked to the sky and found Nufti. He couldn't move a muscle, except for breathing, while he watched true wings command the ocean of the air. For awhile, Nufti pretended not to see Topi. He took his circles higher and higher until he was only a speck in Topi's eyes. When he threw away his tease, Nufti folded his wings and made a dive which took him like an arrow made of wind and brown light over Topi's head. So close did he come that Topi could hear the talk of Nufti's feathers with the air. The hairs on Topi's head tried to follow Nufti as he climbed into the sky again, the sun tipping his wings with some gold. There were more dives on Topi. Then Topi chased Nufti and the shadow of Nufti. Sometimes, their bodies and their voices seemed to mix into one body, one voice. Then they became an earth-sky creature...like some of the images Nuk-Chuk had seen in the Old One's castle.

Their play took them closer to where Topi had heard the calls of the strangers. Once, when he was far above Topi, Nufti saw the quick movements of another one behind the big rocks near the lake. The sun colored this one pale gold, and it needed no voice to speak of strength and swiftness. Topi couldn't see this...but Nufti saw it. Then, where a spear of sunlight struck the forest bed, Nufti saw another one like the first, a great silent strength moving fast to bring a hunter to another hunter.

Topi's game had now changed from race to hunt, and he had now come close to the place that would show him the faces of the hunters. Nufti knew this. When he dived on Topi again, he brought a warning to his friend by a great flapping of wings and cries which tried to tell of the danger. He flew a short way toward the village and then back to Topi. This was a good warning, and Topi understood some of it. Nufti's wings and cries had also stirred the memory of the calls that had challenged him like arrows from across the lake. No, he couldn't leave this place while the bowl of his strength was still full. It was time to start to pull the breath from the chests of the boastful strangers.

The signals of danger to Topi had been very strong; strong as the bonds that held Nuk-Chuk to his brothers. Even before the calls had been born in the throats of the hunters, some of these signals had traveled to Nuk-Chuk. They had come to him faster than a drum sound, or words made by smoke, or signal fire. These signals had pulled Nuk-Chuk from his bed and to a corral which now held only the troubled whispers of the morning air. From his thoughts, he couldn't make any true images of Topi's danger. He couldn't find Topi among the hundred places that now flooded his memory, but he had eyes to find a trail and he had legs that could try to eat big pieces of this trail and bring him quickly to the danger he would share with Topi.

The signals of danger had also come to another one. This one *could* make true pictures from them. He knew that Topi would need more than even an eagle of horses could bring to the game that was now starting. He knew that the thread of Topi's life could be cut before Nuk-Chuk could find him. The Old One made Keena know about the danger, and about the place of the danger. Not long after Topi had started his dance as king of the

water smashers, a great white dog shape had started to travel toward Topi. When Topi picked up the challenge of the game again, Keena was already waiting near the place where Topi would come to the big rocks and the trees. The sunlight that now made pale gold on the bodies of the hunters could also show a bright warning of teeth and eyes from Keena. A *teacher* of hunters had now joined the hunting game.

Nufti could do nothing but fly above Topi and try to be his scout. When he saw the body of the mountain lion pressed against a flat rock that looked down on Topi's trail, Nufti made a scream that pulled the mask off the hunter. Even before the voice made of pieces of angry wind beat against the rocks, Topi finally

knew of his danger, but he didn't know *where* the danger was. He could go forward, or backward. Just before the lion's voice crashed down on him, he made a great leap forward. It was the wrong guess, it took him underneath the golden power of teeth and claws aimed at the target of his body.

Topi had brought a peaceful challenge of swiftness to the strangers, but they had rushed upon him with a terrible game he didn't understand. His life could be taken as token for the winner. A great fountain of fear pushed against his chest, but he fought the fear and made some of it into fighting strength. Still, the weapon of his swiftness was no weapon on the narrow, twisting band of earth between the rocks. The breath of the night had made it slippery and small stones tricked his feet. Great claws that could grip the earth were needed for fast travel in this place.

Topi felt the lion strike his flanks and try to pull him down. He made hammers of his rear feet. When he lashed them out, he heard a sound made of pain and anger. He also felt the solid body of the lion. Then Topi ran again, trying to find escape from the trap of the rocks, but there, if one trail was true, two were false, and the footsteps of the traveler could quickly turn into laughter from the faces in the rocks. When he came to a fork in the trail, the lion was as close to him as the length of a claw and he tried to drive Topi into a false trail where the game could be ended, but Keena was waiting there. His body blocked the false trail and showed Topi the true one. After Topi had passed, there was a great coming together of a lion and a chief of wolves. For the lion, tender horse had suddenly changed into a storm of fangs that seemed to cover him. There was some trading of fur and blood before the lion backed down the trail, wondering about the white storm that had just struck him on his own battleground.

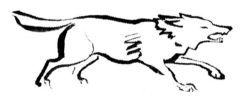

Keena found Topi standing where the forest left some room for a big rug of grass, and a big door above for the sunlight to enter. Nufti was also there, but there was no rest for these tired warriors. Nufti was making a big noise again and also fierce dives that took him like an arrow through the pillar of sunlight and into the shadows of the forest. Topi had made a statue of himself again and his head was pointed toward the target of Nufti's arrows. The signals of lion were very strong in that place

and they pulled the hairs on the back and neck of Keena. He sent a voice like small thunder rolling across the grass to tell Topi that he had come again.

The sounds of the first battle had come to the second lion. Quickly his stomach was getting too small for a big meal of horse. The great dog shape that still held some trophies of the first battle—and looked to find more—also helped to shrink his stomach.

When Topi knew that Keena had brought his gift of strength again, he reared and pawed the air and threw the challenge of his own voice to the lion. Nufti added his voice to Topi's. And when Keena made some more of his special thunder, no lion could stand against this warrior who was made of three big parts…so he ran into the forest.

Topi carried the marks of the lion on his flanks and back. Nufti had left some of his feathers on the trail near the first battle, and one of them in the shadows of the almost second battle. Keena would have much proof for the Old One that he had listened to the words about danger to Topi.

On that day, Nuk-Chuk had fought his own battle against fears for Topi, against a crazy trail that laughed at legs which were not almost wings and seemed to take him everywhere across the Land.

When he had pounded almost all of his strength into Topi's trail, he saw the end of it. It was walking slowly near the top of a hill, and it was almost black against the brightness of the sky. When he ran toward the one who had pulled him into that day of battles, he saw two others. One of these wore a coat of feathers and he was riding on Topi's back. The other one, a great dog shape, was walking next to Topi. All of them wore some honors of battle.

Finally, when there were four who walked toward the village, Nuk-Chuk couldn't find any words for his brothers, but his heart was full of them and of another who watched these warriors from a lodge inside a mountain.

There were marks for all of the warriors on the wall of his private place. Topi's was the lowest one, next to the first head mark. Then came Keena's...then Nufti's, next to the second head mark. How could he tell about these marks coming together in a battle that gave *all* of them honors? How could he tell about the Old One who was also in that great coming together with the lions?

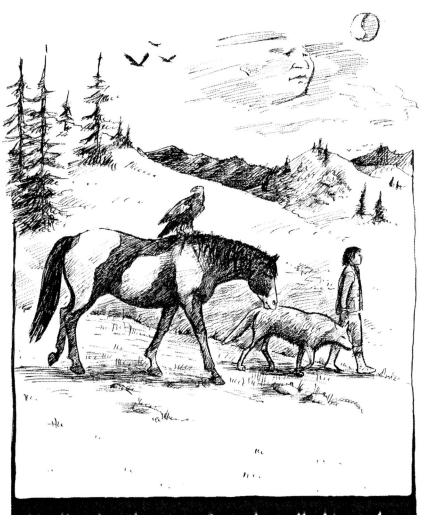

Finally, when there were four who walked toward the village, Nuk-Chuk couldn't find any words for his brothers, but his heart was full of them.

Nuk-Chuk had been pulled into a trail that had almost sucked the life out of him, but the others had finished with the danger before he could get there. Should this be a part of the telling? There was too much complication here to push into a *new* mark. He would have to stuff this battle into his memory.

Anyone looking at this brave who had been late to a battle, at the way his fingers and his eyes roamed around the marks on that wall, would know that his brothers— and the Old One— were making his memory a very crowded place.

# 11. THE VOICE OF THE OLD ONES

"Nuk-Chuk...Keena is waiting for you. He is on the hill beyond the lodge." His grandfather's voice was soft. Even so, it found the ears buried under the sleeping robes. When Nuk-Chuk's head popped up, he saw the little pieces of the dawn light that danced in his grandfather's eyes. They made the old face look like a young brave's again.

Nuk-Chuk dressed quickly. His hands trembled a little as he tied the thongs of his moccasins. When he was done, he turned to speak to his grandfather, but there was no one else in the room. Where his grandfather had stood there was a buckskin belt that had the beads of black crystal and the ivory clasp like the head of a hunter bird. He wondered about this, but he put on the belt. He went out of his lodge and started to climb the little hill. This hill wore a crown of dawn light and the eyes of a great white dog shape gave two jewels to this crown.

Keena stood like one of the statues in the Old One's lodge. Then a breath from the mountains stirred the fur on Keena's neck and back. Nuk-Chuk ran to him and when he buried his face in Keena's chest, he heard the sound like far away buffalo pounding an ocean of grass. After his greeting, Nuk-Chuk stood at Keena's head. Why had Keena come? Keena answered by turning his head toward the mountains, and then he trotted swiftly to another hill. There he stopped, and looked back, and Nuk-Chuk heard the call from a castle.

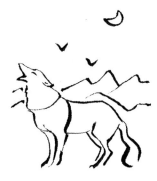

His trail to the castle would need Topi. Also he would bring White Fawn to the place where the spirits of the Old Ones danced with lamplight across furs and rugs made of rainbows. He shouted some of these things to Keena, then he waved his hand and ran down the hill toward Topi's corral. Topi was sleepy, but when he felt the hands and then the legs of his brother, and heard the words about Keena and the Old One, he forgot sleep. He filled his lungs with cool air and made a little dance that almost tossed Nuk-Chuk into the sky.

White Fawn was more than a little sleepy. Her mother had strong words for a brave who came with the dawn and made crazy talk about a white wolf and castles and an Old One, a brave who would take a maiden from warm sleeping robes into

a day that was mostly old night. When White Fawn could find her own words, they splashed her mother's ears as much as Nuk-Chuk's had done. Then there was a quick finding of clothes, a filling of a food pouch, and a running out the door of her lodge to a brave who was waiting with a wind kind of horse.

White Fawn buried her face in the warm buckskin coat of the one who rode in front of her. The air was cold and it was a little time before her arms and legs remembered their strength and her body became as one with Topi. He plunged through the dark places and climbed swiftly toward a fountain of light that was spilling down the hill to chase the shadows of the night. At the top of the hill they stopped. They were ready for this new day. The eyes of a brave and a maiden and a horse held some of the brightness of the young sun. They also held the image of a great white dog shape that was waiting for them.

Up the belly of the valley they went, crossing shadows of the mountains and broad rivers of gold light that washed the sleep from the grasses. Sometimes, Keena was a ghost shape swimming in the patterns of light and dark, daring them to find him. Sometimes, he trotted close to Topi and the shouts of White Fawn and Nuk-Chuk fed Topi's strength. At the head of the valley, Keena entered the wall of the forest. He led them between the legs of the giants and through dark fern pools. White Fawn remembered the talk about the fern fish and she couldn't stop a little shiver and moved her face closer to the coat of the one who had seen these fish. Keena found a good trail for them. Soon, they passed through a door in the forest and went out to the meadow that covered the feet of the Old One's mountain. The sun was old enough now to toss a blanket of light and warmth over the meadow and the rock wall above it.

Nuk-Chuk and White Fawn leaped from Topi and chased him into a treasure of grass that still sparkled with water jewels left by the night. They found a little spring and they made it ripple with their hands and their noses. When the spring became a mirror again, White Fawn's face smiled in it and, for a moment, there was a brave's face in it, too.

"This is *almost* good enough for a private...*secret* place," White Fawn said, as they rested on the soft rug of the meadow. She touched the brave with the tip of a stalk of grass after she said that. She also teased him with tiny lights the sun had made in the pools of her eyes and the blackness of her hair. Nuk-Chuk had sometimes talked about his private place and he had teased her about this special secret of his as the head marks climbed up the wall of his grotto. Once, he had almost taken her there, after Keena had saved them from the fire cloud. And there was another time—after they had found the crystal garden—that he almost took her there. She could have kept his secret. He knew this. She knew this. She also knew that a brave has to have a spot of the Land where his words and laughter and silence can flow together without anyone's big ears pushing in on him. So, she didn't complain about this secret of his, but two could play at the teasing game.

"This is a *two person* secret place," Nuk-Chuk said, as the beauty of the meadow, the mountain, and a maiden swam into his eyes almost at one time.

"No place for the *marks* here," White Fawn said. The brave had also mumbled a little about the head marks, and about some special marks which, she thought, might have some of her in them.

"Here it is only for thoughts," he said, placing a flower of clover in her hair. Then he took her hand and pulled her to standing. The tiny beads in the deerskin band around her head winked at him as he did this. He noticed these winks, and also that, standing as tall as he could, the top of White Fawn's head came up to his eyes. If he had done the head marks for her, she would have pushed very close to the ones his grandfather had done for him.

"It is time to go," he said.

Keena had not waited for them this time. Nuk-Chuk cupped his eyes with his hands and studied the wall of rocks. They walked along the wall for a long way, but no faces in the rocks talked to Nuk-Chuk about a trail to a castle.

"Look! Look!" White Fawn shouted. She pointed to a place on the mountain they had passed. From the rocks far above them, they saw a thin plume of orange smoke rising into the still air. Against the grayness of the rocks, the plume made the strongest possible signal for a pathfinder who had lost his path. When White Fawn looked at Nuk-Chuk, there was a crooked little smile on him, and there were no words around his mouth. He only took her hand. Then they walked back over many of their steps. When Nuk-Chuk finally remembered the rest of the trail, they started to climb toward a castle.

Nuk-Chuk's eyes were like Nufti's now. The Old One had teased him and this had put new strength into his arms and legs. His and White Fawn's hands joined many times; he traveled too fast for her, but her smiles, even some laughter, were much bigger than her fears, or the complaints of her body. When Nuk-Chuk pulled her to the flat place near the door into the mountain, the

wind had broken the orange smoke of the Old One's tease into little pieces and taken them away.

They rested on the cool flat rocks. Topi was a quiet spot on the meadow far below. They saw him, and they also saw the shadow of a great bird pass over him.

"It's very hard for Topi to hide from Nufti," Nuk-Chuk said, throwing a big smile toward his brothers. Then, he turned toward the mountain and became a pathfinder again.

When their eyes were big enough to trap the light, White Fawn gave a little gasp, and then a cry of excitement, when she saw the carvings and the strange writing marks on the rocks. A few times, Nuk-Chuk let her touch the images. Mostly, he pulled her deeper into the mountain, into shadows that grew bigger and darker, but these shadows held no fear for him now. Soon, they entered the big room where he had listened to the words of his father and grandfather. The eyes of a maiden were as big as eyes can get. Her breath grew quicker with every step into this great mystery. She didn't know that she pressed her hand very hard to the hand of a brave who was now waiting for a fountain of light to push away the shadows.

It started as a thin ribbon of gold against the blackness, then it was a spear of light that struck the sand near their feet. Then it was a fountain of light that held the tall image of the Old One. A soft voice with a smile in it came to them:

114

"It is good that eyes that can hold the beauty of a princess can also find the trail," the Old One said. When he said this, Nuk-Chuk could see that the light had trickled some special sparkle into the Old One's eyes, and he knew that this was part of the tease game they had all played outside the mountain. Then the Old One took White Fawn's hands in his hands and he looked into two eyes filled with wonder. "I think that *this* one will also find other trails that have hidden from many eyes." This was a proud chief's voice, but the softness in it and in the hands and the face that came with the voice made a little smile sprout on White Fawn's face. This quickly grew into a big flower of a smile that needed *three* faces to hold all of it.

"She has a very big curiosity...also she is very stubborn," Nuk-Chuk said, trying to make a frown, but it wouldn't come. His eyes had to dance with the little lights that White Fawn's necklace of crystals was sending him.

"My secrets may not be as big as the ones you have already found," the Old One said, when one of the tiny arrows shot by White Fawn's necklace dared to come to his eyes. "But I will try to make some of mine *almost* as big as trees of crystals, and a rainbow under a mountain." Nuk-Chuk and White Fawn looked at each other, trying to answer the question of eyes that could look inside a mountain and see fireflies in the garden of a giant. The Old One turned and led them into his lodge.

Nuk-Chuk filled his eyes with treasure he would never forget. White Fawn gasped again and again and there were many more cries of discovery for her. Keena stood in a far place of the big room. Except for the lamplight that tried to become fierce in his eyes, he could have been one of the statues there. But he didn't

fool White Fawn. She ran to him and made him a necklace of her arms. Keena didn't wear necklaces, but he accepted this gift from a princess, and he made the far buffalo sound in his chest for her ears alone.

A thousand questions splashed the Old One's ears, as White Fawn and Nuk-Chuk moved among the treasures that covered the floor and the walls. Their hands and eyes traveled over writing marks and over the half shapes on the walls. There were also full shapes, standing away from the walls. Some of these were taller than the Old One. A few of these marks and images they remembered from the sand castle. Most of them were of a strangeness that was beyond their thoughts.

There were birds and animals here that must have ruled the

Land and oceans of air and water before man was born. There were shapes that had bird parts and animal and fish parts mixed all together. These told of a fear and power from which no man could hide. A few of these had faces like men. And when the lamplight moved shadows across them, White Fawn was very glad that some trails had been forgotten, although there was much more beauty than fear for them here.

Many of the shapes were carved from great pieces of ivory. The carver had brought a form to them that needed only breath to give them life. Sometimes, the play of the light and shadows did bring the life of an instant to them. Then, Nuk-Chuk and White Fawn expected to hear the sounds of wings, or feet, or to hear voices that must have shouted at the birth of the

mountains. Also, the carvers had found beauty in pieces of the black crystal and rock. Fingers, even faces, were called to the smoothness, the almost life of these images. If there were names for the images they didn't know, the Old One told them. He showed them other rooms where the makers of the images had grown impatient with only rock, or crystal, or ivory. Here, they had blended these materials together to find the truth of their work.

"*Gold*" Nuk-Chuk whispered when they came to the last room of the carvings. There was some of this soft, yellow stuff in the sands of the Dragon and sometimes the People made little beads and ornaments from it. Mr. McPherson had talked about gold, but he always hurried on to better treasures. Here, in this room of the Old One's castle, there were no little beads, or rough pebbles. There were great *plates* of gold, and these plates were fastened to a wall of rock in such a way as to make a long picture.

This picture was about the People. It was about the life the People had found on the Land, and on the water, and under the bowl of the sky that was over everything. The start of the picture was served by the light of lamps. In the restless air of the room, this lamplight moved over the plates in patterns of light and dark that changed beauty to another beauty. It seemed to give a life to the carvings frozen in the gold. Near the end of the room, and the end of the picture, windows had been cut in the rock. These windows had been made so that, from dawn until sunset, the sun could bring some of its own treasure to this part of the picture. Now, the sun was at its greatest strength, it made a brightness on the picture that was like another sun and White Fawn and Nuk-Chuk had to turn away from it.

"If gold is so precious to some men, then this must be a very great treasure," Nuk-Chuk said to the Old One when he could finally speak.

"It is precious because of what has been made from the gold," the Old One said. "The gold was used because it is very good for making such a picture...and because it will live as long as there are men to see the picture." The Old One looked at Nuk-Chuk and then at White Fawn as he said this. Then, he turned toward the part of the picture that was buried in the sunlight and he walked along the picture almost to its end. He stopped and turned back toward them. Then he held his arms apart in the directions of the length of the picture and the sunburst behind him made a headdress that only the *greatest* chief could wear.

"We will play a little game," he said. "You will tell me what you find in this picture. If you can find some of the truth that is in the gold, then you may take to your lodges any treasure of mine that pleases you and that Topi will agree to carry." White Fawn's little cry of delight was stopped by more of the Old One's words. "Truth can be as easy to find as Topi in a field of clover...or it can be harder to find than anything in this world. Sometimes after it is found, it can bring battles that only the strongest hearts can win. Today, we will only look for *little* truths...and *little* battles." Then the Old One's eyes did another dance with Nuk-Chuk's and White Fawn's.

"If we lose this game, what must *we* give?" White Fawn asked the Old One. Her voice, and all of her face that she had put into that question, showed that beauty and excitement can live with truth and duty.

"Then *I* will also be the loser...and sadness will be a penalty we will share together." It was the softest voice they had ever heard, but all of its words had come to them.

"This is a very strange game. It gives only winners, or losers," Nuk-Chuk said, scratching the head that had just found a game to match the wonders of this castle. He and White Fawn walked toward the start of the picture and studied it. Their fingers moved over a skill of carving that was a forgotten glory of the People.

"There are humans being chased by terrible shapes that come from the earth and the sky," White Fawn said, as she started to play the strange game.

"...The humans are running into holes in the mountains," Nuk-Chuk said, as his eyes and White Fawn's swam close together over the gold.

"The first plate tells of fear and of humans who live like animals," a maiden said with a very serious face and a voice like  a whisper.

"There is a sorrow and a blackness here that even the gold can't hide," a brave said, who was looking at a memory he was very glad the People had forgotten.

They came to the next plate and were happy to leave a blackness that still lived; though a hundred million suns had come since then.

"Look! Look!" The humans have come out of the mountains! Here is a village. Here is a lake with big canoes!" White Fawn's

fingers and eyes had discovered a world that had pushed away most of the darkness.

"There are fish traps like our own in the river, and near the shore of an ocean. And the humans have found weapons for hunting." Nuk-Chuk's eyes danced around the plate.

"...And here the lodges have become very big and fine. I have never seen such buildings...not even in our books!" White Fawn said, when they came to a plate which showed them a world that had already gone beyond their own.

"There are rivers that run very straight between the lakes, and many smaller ones that seem to feed great fields of plants." Nuk-Chuk's voice showed his wonder at this world that now only the gold remembered. As they came toward the end of the picture, the plates made their words came so fast that they made almost one voice:

"They are carving some of the images we have seen."

"These look like machines for making cloth and rugs."

"Their horses are very fine. Here is a great herd of cattle...and storehouses for grain."

"...Some of the buildings have long covered passages between them so that the humans can walk without the rain, or the sun's heat."

"Oh...the mountains have moved! There are great cracks in the earth...and they have swallowed some of the buildings!

The humans are running everywhere!  The animals and the humans are running everywhere!"

"The humans are fighting!  Many of the fine things are still there…but they are fighting…they have forgotten their glory."

"…There is a darkness in the gold again. The animals have gone. The humans have run into the mountains again!"

They had come to the last plate of the picture and the sun still burned in it. They searched it for answers to their questions, but there were no more carvings.  Only a brightness of sunlight that waited for the promises of the gold. They had seen a picture whose head had caught its tail. They had seen a greatness of the People which the People had forgotten.

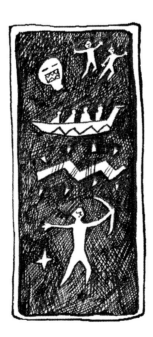

Words couldn't come to them for awhile. Their thoughts pounded their heads like the ponies had pounded the corral. Nuk-Chuk was the first to catch a thought and to make words for it that went to the picture:

"A *strength* was broken. When the Land was angry, a strength was broken and the memory of the People was too short."

"This strength must always be fed. There must *always* be ones who can keep the good memories in brightness and to teach the lessons of the darkness." White Fawn's words also went to the picture. However, none of the words—neither hers, nor Nuk-Chuk's—could hide from the Old One.

When the two hunters of secrets turned toward the Old One, they saw that he stood like one of his tall statues. His face was like some they had seen in a picture that had looked into sunrises and sunsets beyond any memory. When his voice finally came to them, it was made of voices that had spoken to them from the ivory and the crystal, from the joys and the sadness frozen in the gold.

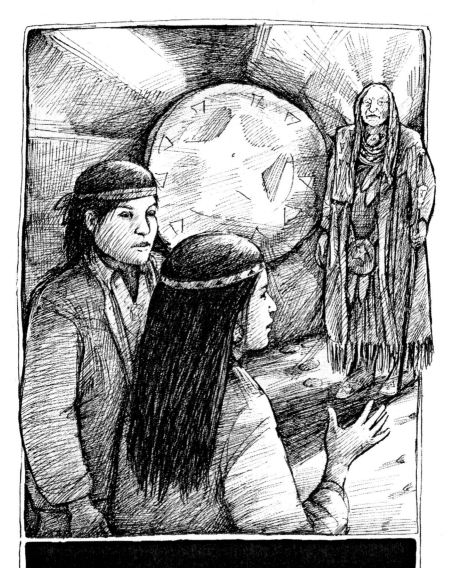

"There must always be ones who can keep the good memories in brightness and teach the lessons of the darkness."

"Today, you were supposed to look only for *little* truths…*little* battles." He started to walk toward them, and a smile was at the end of the world from his face. His voice came closer to them:

"…You have found the *biggest* truth that is in that gold, and the battle you have found is the *biggest* that the People can find in their lives."

He kept walking toward them. There still wasn't any smile on him, so they couldn't look at him anymore. When he stopped walking, he was very close to them. He touched the top of Nuk-Chuk's head, then White Fawn's head, so they *had* to look at him. Then they saw that a smile had finally found him. Part of this smile was for a brave and a maiden who had heard many voices that day. The rest of the smile—aimed at the *same* faces—was for a young chief and a princess who had also heard these voices…and would *always* remember them.

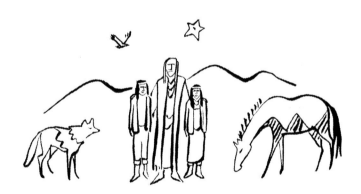

# ABOUT THE AUTHOR

A Southern California native, Gordon Zima attended Stanford University and Caltech. Following a career as a research engineer, largely in defense laboratories, he has been trying to prove that non-technical writing is a good energy outlet.

Gordon Zima has also been developing some adult fiction themes, including: *Other Whispers*, a novel about an engineer's life; *The Ivan Spruce*, an international saga that tangles an emerging, better, Russia with American consultants; and *The Red Garnet Sky*, an historical novel about one of the most fascinating men of history, Hannibal Barca of Carthage.

# ABOUT THE ILLUSTRATOR

Paula Zima treasures the memories of being read to by her parents and grandparents. The stories came alive with their voices. Best of all were the ones her father made up fresh, in the half dark, puffing slowly on his pipe…he called them *The Nuk-Chuk Stories*.

Paula paints and sculpts light hearted people and animals, and also creates commercial illustrations for packaging. This collaboration with her father is her first venture into book design and illustration. Her work can be viewed at *www.paulazima.com*.

Printed in the United States
46529LVS00007B/325-348

9 780974 289496